The Century Hit Puberty

Some Essays 2010-2014

Mat Gleason

THE CENTURY HIT PUBERTY
By Mat Gleason

Copyright © 2015 by Coagula Publications – a division of Flechaverde, Inc. All rights reserved.

ISBN 978-1502808745

This book may not be reproduced in whole or in part or in any form or format without the written permission of the author.

Published by: Flechaverde, Inc.
P.O. Box 5228 , Huntington Park, CA 90255
1-424-2-COAGULA
www. coagula. com ● 88gallery @gmail. com

Coagula Art Journal #112 ● August, 2015
Copyright ©1992, 2015 by Flechaverde Inc.
All Rights Reserved

Coagula Art Journal is published on occasion by Flechaverde, Inc who is solely responsible for its contents. However, any opinions expressed within the fair confines of *Coagula Art Journal* do not necessarily represent the views or policies of this journal, its owner (Flechaverde, Inc.), or any of his agents, staff, employees, members, interns, volunteers, retailers, distributors or distribution venues.

Bylined articles and editorials represent the views of their authors. Unattributed editorials are the opinion of the editor at the time of their composition.

All correspondence (email included) becomes the property of the publisher and cannot be returned (or erased). We retain the right to accept or reject all correspondence, in any form, primarily but not exclusively for purposes of publication.

Coagula Art Journal retains the right to reject any advertising and to adjust advertising rates on any basis without any notice. We are not responsible for any claims made by our advertisers.

Coagula Art Journal is distributed manually, electronically and in formats that might be spontaneously embraced. Placement in a locale in no way implies an entity's sponsorship of, liability for or attachment to this journal. Distribution location maintains the right to distribute this publication for the price it chooses—for purposes of import duties and value assessed each issue, the wholesale price of one copy is $13.00

*I've had a few mentors in my life that I could call friends and this book is dedicated to two of them,
Llyn Foulkes and Roland Reiss*

ACKNOWLEDGMENTS

This book starts with an essay from January, 2010 followed by one from December, 2014. Everything else here was written and published at some point in between. I believe decades are as overrated as measurements of time as half-decades are underrated. I was born in 1964 but that year had more in common with "the fifties" than it did with the mass consciousness agreements on what comprised "the sixties". So slicing things finer, I believe, reveals something truer about an era (or mini-era). So here is five years of my writing from the first half of the pubescent decade of the twenty first century.

Early in 2010 Carol Es introduced me to Kimberly Brooks, the editor of the *Huffington Post* Arts section. This venue attracted many more readers than I had ever had in print and the luxury of an audience inspired much of what is included in this book. Kimberly was supportive of my writing and defended it when complaints arose. Of the three essays that were rejected by the website in this five year period, none were, in hindsight, really worth including here, perhaps an indicator of the bar they set for me. Thanks are in order to Carol and Kimberly as well as Travis Korte, Mindy Brocka, Priscilla Frank and Nicole Campoy-Leffler at the HuffPo for their assistance in getting many of these pieces first published online.

Stuff published here also appeared in *Coagula Art Journal* in print and online and on the *Coagula* blog hosted on the LiveJournal blogging site. One essay here is from the *Halos Heaven* website where I write about sports almost

every day under a pen name. One essay here is a juror's essay for a show I curated. I did a shit-ton of curating at art spaces in this half-decade and after each show ends, poof, it is like it never happened—so here was one relic.

The second set of eyeballs for most of this work has been my wife, Leigh Salgado, who edits a lot of what I publish and who, when she sees a newly published piece that I did not ask her to check, often hollers from her office across the house "I see some typos!" True love found me even if we disagree on punctuation placement near and around quotation marks.

Thanks are in order to Tim Youd, with whom I hit the galleries and museums in Los Angeles over many years and had great discussions about what we had seen, forming lots of the ideas you will read here. Gratitude to my gallery director Bryan Chagolla, Tyler Bleszinski at VoxDotCom, Alberto Miyares, Sean Capone in New York, Wendy Sherman and James Scott, Matt Kennedy, Ed Forde, Tom Callinan, George Joachim, Kristen Carlson and the Carlson family, Scot Ezzell, Lauri Firstenberg, Matt Couper and Jo Russ in Las Vegas, Mike Prusik, Tom Tyson, and everyone else who played a part in getting these essays composed.

It is yours to enjoy.

<div style="text-align:right">

MAT GLEASON
December 30, 2014

</div>

Chapter One

THE ART WORLD

There really isn't any advice you can give an artist besides "Make great art and forget the noise." So my rule is to write something that isn't noise, something that can be deciphered. The enemy in art writing is that nonsensical jargon which strives to separate a pointless elite from the aspiring masses. Ah, but every cult must have its peculiar codes and rituals. The one thing the art world does not have is a formal initiation and so perhaps my essays are a way of having your idealism removed, like they do a foreskin cut—something you hardly remember because you are so young when it happens but something that stays with you for the rest of your days. So you might lose a little idealism about your art world road trip, but seeing what I have seen will help you spot the road bumps ahead.

You Genius You..8

Are Art Fairs Eclipsing Art Museums?..........10

The Art Community Does Not Exist.............13

In Praise of Sky High Auction Prices.............16

Regulating Art Markets
 Saves Billionaires Millions!..................19

Street Art Market Collapse
 Would See History Repeat...................22

Is *Pacific Standard Time* Too Big to Fail?...........25

Mystery Museum Insists It Be Ignored..........29

What Artists Need to Know About
 Gallerists Staying Current32

Why Art Critics Really Hate Art Fairs34

The Art Collector Youth Fixation Factor........37

Art Fair Pests Are Everyone's Problem41

The Career Benefits of Boycotting
 Charity Art Auctions.......................43

My Archives...................................46

You Genius You

With the changing of the odometer to a new decade we are all supposed to look back and summarize what just happened, maybe even distill it down into a few artists or a handful of movements.

But you don't have to do this now and I am not, and you may not really ever do it in hindsight as the years go on. If cancer is cured next month, the last ten years will look like the Stone Age. We have to write the history of it sometime, but look back on how the recent histories have been written and there are gaps, often ones larger than ten years. And as the blob in the rearview mirror turns into a dot, we are probably wise to be looking through the windshield of time instead of backward anyway.

And I am doing you a favor here.

The longer it takes to digest what went on in this past decade that was actually significant, the more likely it is that you will come to be seen as the most important artist of the decade.

Think about it... Van Gogh defined the 1890s, but in history's hindsight. You may have been struggling in a few lousy group shows highlighting an otherwise studio-bound decade. Maybe there is little difference between you and Vincent. You and Van Gogh are both undiscovered geniuses to be adorned as the light of your respective decade – only just years after some of your fellow travelers and their descendents caught up with your brilliance. Yep, you and Vincent, misunderstood in your own time.

History is not written in an instant. Damien Hirst and Jeff Koons will more likely be piled into storerooms with Parisian Salon painters from the 1890s than they will

ensconce the halls of culture a hundred years from now, where your work will of course be heralded and the text on the wall will be sure to scorn and mock me and others for not writing about you, the artist of the first decade of the Twenty-First Century.

And one day the museum will flood and they will race to save your work and they will lament the storerooms full of worthless tripe. They will pull it all out and auction it off in order to buy a better filtration system to ensure that your work will last for future generations, but the auction will create a stir, and people will rediscover Koons (Hirst's work having completely disintegrated) and Schnabel and some others and suddenly, there will be a debate about the merits of YOU and your epic turn-of-the-century style. The debate will be about how perhaps maybe you have become too synonymous with those days of yore, those simplistic times and perhaps these undiscovered artisans need a second look. Oh the debate will rage, but this time, you will be the establishment and the billionaire babies club of today will be the underdogs. At the very same time, the historical society will be getting sued by the property owner of your old studio. He wants to tear down your historic studio space in order for a new development. He promises to recreate your studio in a wing of the museum and now the forces of revisionism have a battle cry: were you really the most important artist of your decade?

Well, were you?

Or is your best work ahead of you? Are you about to go into a period of output whose genius will make Picasso's Blue Period look gray? Will the "Twenty-Teens" be the time that is synonymous with your name to future generations?

What the fuck are you reading this for? Get to work!

● January, 2010

Are Art Fairs Eclipsing Art Museums?

The decade is half over. The century hit puberty. Did anything else happen? Of all the things that occurred over the first half of the decade in the arts, what will be the most impactful at the end of the decade? It is hardest to see from the middle of it all but I will take a stab.

Art moves slowly. Art institutions move glacially. Changes in art take decades to register as significant. When the hype dies down, what is left in its wake is not what we thought would be there when the party started. Changes in the ways institutions commandeer and keep power in the art establishment happen over half-centuries if not full ones.

Earlier this decade I thought I spotted a trend. It seemed that art fairs were replacing art galleries as the main place to see contemporary art. The foot traffic of people "making the rounds" at commercial art galleries is down according to many onlookers. Many excuses, from the recession to the internet, are given. Meanwhile art fairs were on the ascent. The ability to see a hundred or more galleries from around the world in one place seemed to be the new normal. But in the bigger picture the trend I see developing is not art fairs replacing art galleries. The trend I see is art fairs replacing art museums, specifically museums of contemporary art.

A few decades ago, museums of contemporary art were all the rage. As "Museums" they had all the prestige of ancient civic institutions. As "Contemporary" they had all the glamour of being the de facto trendsetter in visual arts. What MTV was to rock and roll in the 1980s, museums of contemporary art were to visual culture: they decided

what was the important art of our time and delivered it in seriously curated museum shows.

But time marches on. Large-scale art fairs such as Art Basel, Frieze, The Armory and Art Miami have usurped much of what made museums of contemporary art so exciting. They deliver an endless orgy of the world's top contemporary art. That they only last one week in a specific location only adds to the frenzy, the "must-see' nature of absorbing the art of our times. Museum exhibits can last for months, and once the precious real estate is taken up with a scheduled show, the art of our times can get pretty old pretty fast. For every exhibit that draws people for a return visit, there are five that get half a look, an eye roll and a beeline to the gift shop.

The biggest criticism of art fairs is the central theme of money. That everything on display is for sale upsets art purists beyond hope. And yet only a small percentage of major art exhibitions at museums of contemporary art are devoted to artists not in the orbit of big money galleries. The boards of trustees of these museums have innumerable connections to the art world that influence what is being shown on those white walls that are assumed to be sacred.

Art fairs have become the unquestioned driving force of the art world in the past five years. They are forcing the world's leading galleries to expand into bigger quarters. The top commercial galleries have built giant exhibition spaces in the past few years to accommodate art that fits in with the aesthetic demands of art fairs. These new mega-galleries make the grand museum halls of our public institutions seem quaint and ordinary.

If museums with contemporary art programming are to survive, can they learn anything from art fairs? Can they create an environment that offers a multiplicity of choices

for today's engaged viewer? Instead of eschewing spectacle, can they take some of the overhyped dazzle lauded upon the starchitects that design some of their buildings and instead give the public spectacular exhibitions? Can our museums liberate curatorial agendas from the nerdy clutches of academic curators and myopic historians?

 Museums of contemporary art freed the art of today from the fuddy-duddies who oversaw yesterday's art. But in the shadow of mega galleries and dynamic art fairs our once vital museums are becoming ossified. These institutions need to change with the times in order to be relevant tomorrow. Collectors who once donated large sums to independent institutions now build their own museums—and fill these buildings with art bought at art fairs. This decade is now well into the teens, let's hope museums can follow art fairs and be part of the coming adulthood of the twenty-first century.

• December, 2014

The Art Community Does Not Exist

I got scolded a lot during the early years of *Coagula Art Journal*. Scolded by artists and collectors and art dealers and just random people at galleries with no specific status. They stared me straight in the face. They wagged their fingers in my face. They threw drinks in my face. They would say they were angry. They would say they were disappointed. Some would tell me they were only thinking of my best interests.

They were all upset about one thing. My disrespect for the community.

You see, there is an art community. There is no neighborhood to move into to be part of it. There are no membership fees or initiations. You show up and supposedly you are part of it, right?

Wrong. The "community" of which everyone spoke was an individual illusion to each person.

- COMMUNITY was the hallucination by a heavy drinking bat in her early sixties who had bought five works of art in her entire life insisting that she was a top collector.
- COMMUNITY was the hallucination by an MFA graduate who had never had a solo show five years after graduation asserting that he was a peer of Robert Rauschenberg's.
- COMMUNITY was the carrot the MFA diploma mill dangled at hungry applicants that implied everyone you ever met on their campus would be working on behalf of the art careers of those applicants for the next forty years.
- COMMUNITY was what the lonely painter in his studio longed for without ever really envisioning it specifically to call it that but there was something that made him

set down his brush, take a shower, stay sober in the afternoon and head over to someone else's art opening.
- COMMUNITY was what the woman who dated guys she met at museum opening nights really wanted and it was the reason she never slept with any of them and she never quite put her finger on the fact that she pursued something else instead of the thing she sought because she never visualized what she wanted.

And plenty more people had their own notions of what it was and never quite landed there. Of course, the most evil motherfuckers in the game used COMMUNITY like a worm on a hook to reel in the most earnest suckers—you can get endless free labor from people thinking they are building something bigger than themselves from which they will benefit. I've seen people give up a year of their lives and lots of their money to get one postage-stamp-sized drawing on a wall of a massive group show because some bastard was pulling the strings that spelled out the pledge that a community was being formed.

Do I sound cynical? WELL... here is why I am cynical. The dumbshits and a hundred others would blame my writing for poisoning the community. The one that only existed in their minds. Not their collective minds, that would have been beautiful and maybe changed the world a little. No, each person's individual navigational visions of what the art world was and what he or she could get out of it...IF only a lot of people would work on giving it to them. So I wouldn't foster the party line of discourse or dialogue or whatever grease was making the gears in the machine turn faster that week. And therefore, my writing was an attack on the community.

And my writing was not that. It was an attack on the structures in place that impeded community, structures

these motherfuckers wanted to climb on and climb up and look down on everyone else from before they spit down or talked about spitting down and laughed about the concept of spit. Those structures are all still there, but I wrote enough to assist some people to see what I saw.

There are moments of accomplishment that can only be attributed to group effort. There are synchronicities that unite disparate agendas to push change into the universe. There are commonalities among people that allow them to more easily cooperate on collaborations that make impacts. There are moments when the roaring approval of the many changes the way art is seen. But there is no ART COMMUNITY and in art, the word COMMUNITY doesn't mean shit.

● August 2014

In Praise of Sky High Auction Prices

Read the headlines: The auction prices are rising for top works of art! And guess what, the scolds are out. There are three arguments that the scolds use to bemoan artworks publicly selling for outrageous sums. Each of these arguments is backward and terribly wrong. When art sells for high prices and grabs headlines, the clucking negativity begins from those who believe they know best. But lovers of art should tune them out and celebrate. Let's look at (and debunk) the fallacious arguments making the rounds after record highs for an art auction were reached.

Argument #1:
Money is better spent elsewhere.
A friend of mine posted on her Facebook page:

I value art but this is absolutely ridiculous. I can think of other places to put this kind of money (i.e. clean water, health care, scientific research, education).

This mindset is based on the assumption that money is a guaranteed solver of "problems." Instead of buying a $100 million Warhol, suppose the private buyer spent that money on health care. Last year billions were spent on health care and people still got sick. Where would you spend the money? Choose a disease and you are immediately discriminating against another disease. Cancer research doesn't cure heart disease.

And the worst part of the assertion that art money should go to "causes" is that these causes have billions sent their way each year and yet the "problems" they address remain. I just cannot see the Secretary of Education announcing "Oh darn, we were just $142 million away

from teaching every single child in America to become a rocket scientist but someone bought a Francis Bacon at auction for that amount and now not a single high schooler can read Dr. Seuss." But plenty of people seem set to blame money spent at art auctions for the terrible shortcomings of society. Thinking people everywhere should be afraid when simplistic platitudes become public policy.

Argument #2:
Art is a bad investment
In an historic era where Enron and Lehman Brothers ceased to exist, this hardly makes sense. If anything, big money spent on art brings relief to the economic downtrodden in every other field. Consider this: If the buyer of the $104 million Andy Warhol painting had bought the city block next to your house to develop into luxury condos, your rent would be looking to fly through the roof.

Be glad the money went to a painting instead of helping your landlord be worth ten times what he or she is today.

Argument #3:
You cannot put a price on art
This is a wonderfully romantic notion. When a 19-year old with his or her first sketchbooks makes this profound observation, I take off my critic cap and smile at the wonderment of someone in the bliss-love state of relating to art. It is a state that wears off. The trick is, of course, to not let it wear off into cynicism but rather the understanding that ideals can survive occasionally uncomfortable contexts.

When the auction prices grab headlines, true idealists usually get big-eyed, smile and say "Wow!" It is the cynics

who are pretending to be idealists, that splash cold water over the celebration. Should art be reduced to a dollar sign? Does not great art have an intrinsic value that cannot be defined by money? These and many other questions from freshman philosophy classes are raised with a tone of apocalypse. Should they be?

In Art Appreciation 101, it is common to remind students that Vincent van Gogh never made any money from his art while he was alive. Students are taught that the painters of "The Salon" were becoming wealthy while many Impressionist painters couldn't sell a single picture. Among many reasons for introducing money into the discussion of art, the economic value of art is part of the context in understanding why some art is more valued much more now than in the past. And of course, the opposite happens and the giants of yesteryear sell for a pittance today and that shows us how our values have changed since back then.

But the cynics just want the headlines to go away. Art might get popular and attract more people. The critics of art should be delighted in getting a bigger audience interested in what they write about. It seems their fear of exciting headlines reveals them to be worried that if enough people read about art the public will demand better art commentary.

● November, 2013

Regulating Art Markets Saves Billionaires Millions!

The 20th century's paper of record, *The New York Times*, recently published a long-winded piece imploring (or if you subscribe to the myth that the Grey Lady has clout, "nudging" might be a better word) the state legislature to more heavily regulate various aspects of the commercial art world.

The article describes two areas of the commercial art market that appear ready for more regulation: galleries and auction houses. The suggested regulation for commercial art galleries concerns the absence of a set price listed for the artworks being sold. The second involves the intricacies of bidding for art at auction.

The *Times* got noted East Coast art world veteran Robert Storr to challenge the galleries, saying, "You can't deny someone the opportunity to buy something if the price is posted and the work is unsold."

In actuality, galleries can deny a purchase, and they do all the time for a variety of reasons. If a big collector has an appointment to visit my gallery on Saturday to look at an artist's work, I am not selling that work on Friday to someone who might try to flip it on eBay next month. Should the show sell out and get positive press, it is better to see if the work sells later on than to have a slimy art-flipper get their paws on it. But Storr and the *Times* are apparently on the side of the market's parasitic opportunists—not the galleries and not the artists.

Did a powerful *Times* editor get cornered at some penthouse cocktail party by a fellow one-percenter furious that he or she paid twice what the Joneses did

for a Warhol? (You can bet the pricing regulations would protect the monied from their own stupid social-climbing desperation.)

Notice there is no clamoring to regulate the board of directors at museums from the *Times*. When it comes to regulating art, there is no call in the article that museum board members recuse themselves of decisions that would benefit the value of their art collections. When you visit a museum, the curatorial choices have deep internal politics behind almost every choice and placement. If a collector owns works by a major artist and gets some of these put into a high-level museum show, those works gain in value and the artist's market—which is controlled by collectors, not the artist—generally sees a price increase. In other words, the people who have the most to gain from the regulation advocated by the *Times* are the people who would have the most to lose from the real regulation needed in the art world: institutional regulation.

But we know that is not going to happen; New York is nothing without status-seekers spending inherited money to jockey for better positions in the pecking order.

The second proposed art market regulation is aimed at making the Auction bidding process more transparent (but transparent to whom? The buyer of the art, of course). Once again, the *Times* is spilling ink in favor of the person who can afford to spend millions of dollars on art. There is an old maxim concerning the cause of journalism from Finley Peter Dunne: reporting should "comfort the afflicted and afflict the comfortable." The *Times* twists it into a radical new model: portraying the comfortable as afflicted in order to pamphleteer on their behalf.

When a work of art sells at auction the price is recorded and published and used by thousands of people—auction

records are the de facto method for the art world to set prices. Here is the real power of auctions: Every time an artist's work sells for a new record, collectors at large have assurances that buying work by that artist will turn out to be a nice investment. For art buyers, auction results affirm the suppositions of art history.

If you want to talk about auction regulation, here is one regulation that would level the whole playing field, the super-wealthy be damned. Regulators should insist that the buyer's name at auction be revealed. This would do everyone a world of good, except the wealthy who game the system.

But don't hold your breath waiting for Robert Storr to get on a soapbox in Central Park with your cause on his tongue. You'll never have the *New York Times* fighting your good fight. The powerful are banding together to regulate the commerce of the art world in their favor, your viewing pleasure be damned.

● January, 2013

Street Art Market Collapse Would See History Repeat

Will you be caught holding the Street Art bag?
The euphoria, the rush, the excitement... it seemed so unique, so real, so important, so art historical... until it suddenly felt familiar. Too familiar.

When I heard about the investment banker types being led on tours of L.A. MOCA's *Art in the Streets* show I wondered: How many rich folks will back a street art gallery to acquire deep inventory and never see their money again? How many investment-industry types will be seduced by the glamour of Street Art hype and think they can corner the market? Will they all actually attempt to apply their stupid market metrics to art? None of them will look beyond the majesty of the MOCA seal of approval and ask whether the history books will really be kind to something so prone to trendiness as all this Johnny Come Lately Street Art junk.

Everything marketing manager Roger Gastman touches is turning into gold these days. A lot of it his own gold, of course. And that will continue, feel free to invest in one of his "can't miss" prospects, it will all go up in value, your money, up up up, golden, solid, until the minute it turns into shit. And then everything Gastman touches will all turn into shit, and if you bought that umpteenth Shepard Fairey print from a large edition, you will get caught holding the bag. And it is not just the Obey machine that is on a crash course with history. But let's have a little history lesson, shall we?

Thirty years ago, the people's art was triumphing and the rarefied, elite art world had met its match. The new

art was a pure art, no bullshit. It was big and bold and it ignored academic dialogue and theoretical dissertations. It was raw, it was real, it was a movement with many players who brought in diverse influences to create distinct signature styles all under the banner of... hey, sounds like Street Art, right? Well, back then they called it Neo-Expressionism, and it was authentic as hell.

Suddenly the art market was reborn after a decade of conceptualist conceit had neutered every dollar down to a dull Bruce Nauman neon wall socket light fixture plug. In fact, "plugged-up" doesn't even begin to describe how constipated the art world was. The floodgates of creative excitement that opened with the arrival of Neo-Expressionism ruined the dominance of conceptualism, minimalism and abstraction in much the same way that a decade later the Berlin Wall's crumbling would snuff out Soviet ascendancy.

And as the new players in the art world changed the rules and replaced the old guard, the money and museum certification emboldened them. Everyone was comfortable and everything they touched turned to gold. Up up up it went in value, and that was solid gold, right up until the minute it turned into shit. And unless you were holding major works, you lost your ass. Major works are not prints. Major works are not graphic ephemera, drawings, one-offs or collaborations. When the Neo-Expressionism bubble burst it took a couple of thousand art careers and tens of millions of dollars with it. The art world contracted for about nine years.

Today's absurd prices of "the people's art" and "this breakthrough means of authentic expression" and "commentary on pop culture with an investment value" will all come crashing down. The only thing different is

calling it "Street Art" instead of "Neo-Expressionism." Same crock catchphrases to describe sloppy, mediocre painting, different decade and different conniving slackers playing the role of "the anointed one". What Street Artist out there will retain their value? Don't look to those investment fat cats to pick a winner. Their insipid charts told them Las Vegas real estate was a good bet in 2008. Don't look to the galleries. Their inventory exists specifically to soak investors in a scheme that would be labeled money laundering if the art market would ever become regulated. In boom markets, which the Street Art thing is at this moment, galleries pick artists in the same manner you pick your nose: the biggest available ones get picked and discarded and then there is a digging around for whatever is left that is from some of the same batch as the big one.

There is no denying the popularity of Street Art, much like the late 1970s Disco craze.

Many a connoisseur of Neo-Expressionism wishes they had followed the old adage that Street Art buyers would be wise to heed: Sell when they are buying and buy when they are selling. If you love Street Art, sell it all now. You will be able to buy it all back for cents on the dollar in a few years. Of course, it might look uglier than bad 1980s Neo-Expressionist painting did in 1992, once the "keepin' it real" hype had faded. It might take a decade or it might take a summer but the street art market will be pushed over a cliff. And the art world lemmings are definitely headed in that direction. Remember, the Bee Gees once ruled the airwaves and then one morning they were a joke.

So in light of this superficial disco-era history I've offered, ask yourself, do you really see Banksy's market "Stayin' Alive"?

● May, 2011

Is *Pacific Standard Time* Too Big to Fail?

A friend sent me her Bank of America ATM receipt with its upbeat encouragement to explore the *Pacific Standard Time* website. Could there be a crueler indictment of an art world that is convinced of its moral superiority to mainstream culture than to be subsidized by one of the criminal financial forces that has brought our culture to its very knees?

I was seriously considering a boycott of the entire *Pacific Standard Time* when I saw an entity sponsoring a cultural event after basically destroying the culture via the economy. For BofA to celebrate the very pulse that it now has contributed to killing is disgusting. But the era of the boycott seems to have vanished—instead of the boycott's zero attention, the "occupy" era challenges power by giving perpetrators 100 percent attention. While there is a call for people to remove their money from large financial institutions and open accounts at a local credit union, how do we as a region remove the art that defines our city and our times from the large art institutions? I suppose you don't need an answer to begin your occupation of the art institution of your choice. And if you cannot choose one, don't forget that the big banks collaborate with art educational institutions to profit mightily off of student loan debt. Curricula in the hallowed halls of these capitalist MFA casinos mimic the self-impressed non-engagement aesthetic as much or more than most *PST* exhibits. The anxiety is erased into the conceptual ether. Prozac is to art creation what the Getty is to art curation.

Of course the blandest artists of the era dominate in the Getty's sober SoCal narrative—maybe they're also too big to fail. Instead of a critical examination about how the imbalance of American wealth was mirrored in an imbalance of a few plain-Jane artists getting a disproportionate share of the sales and attention, we get ad agency commercials. *PST* contents itself with insisting some trendy actor go to the museum like your mom crabbing for you to go to mass on Easter Sunday—and implying that art is like Lourdes drinking water and can make local rock stars suddenly erudite.

So who else wants to jump into bed with these perfect bedfellows? Bank of America is a "too-big-to-fail" institution that is under populist attack. The Getty is a "too-big-to-fail" institution that does more harm than good when it waters down an anarchic era into "gosh, golly, gee we're so inclusive this time!" A soul searching of the artists at the top of the *Pacific Standard Time* food chain is much more in order than for those laggards that history forgot and who are being thrown a bone with inclusion in a little exhibit here or a solo show at a dinky institution there.

Let's hold out hope that there is a great *Pacific Standard Time* art exhibit awaiting us beyond these usual two suspects. *PST* is supposed to deliver "the era that continues to inspire the world" (said with a straight face without any reference to Hollywood). What inspires the world? Apparently lots of text and lots of claims that other art is the only thing that influences other art. The Getty should swap places with Taschen. Every time I pick up a Taschen book, I wish I were walking through each page in some oversized museum. Every time I walk into an exhibit associated with the Getty I look out for the staples binding it together, it so resembles a walk-through term paper with occasional illustrations.

Taschen would be a blessing. Europeans actually get Los Angeles. New Yorkers are just embarrassed to be here and try to network during most of their stay to pad their job history for the inevitable move back to Queens. This expansive survey of postwar Los Angeles contemporary art is the brainchild of tired New York academics. In sports, they call this East Coast Bias. The history of the Los Angeles art scene is getting the "gee whiz" media glance that Joe Torre got when he left managing the Yankees for the Dodgers. The clucking of the blizzard and brownstone crowd goes something like this: We just can't believe that everything does not happen in New York and that any person who matters doesn't live in New York, but if you are going to commit suicide (the term New Yorkers use for leaving New York) you may as well enjoy exile in nice weather.

Of course, stupider Angelenos are so infatuated with New York that they roll over and take whatever Big Apple expatriates are serving, not that there has been a single innovation in art in New York since Jackson Pollock (and don't remind them that he did so on Long Island). A gaping hole in *PST* is the reminder that Andy Warhol's soup can paintings debuted in Los Angeles in 1962. But the goal of *PST*'s tiring parade of factotum art shows is for New York curatorial prowess to contain the greatness of Los Angeles instead of celebrating the near century of the west coast's inarguable cultural superiority to New York.

Will anyone else stand up to this cliquish coagulation of tourists showing up to tell us natives that our city matters because a few L.A. artists are so great that their names are known in New York? Like Leona Helmsley feeding filet mignon to her dog, the Getty has claimed ownership of the wildest days and nights of this town's lore and has fed them to the least deserving: academics and advocates of

the international style with no allegiance to the region. No matter how radical the artist or the artworks, the only reason not to bring children to *Pacific Standard Time* shows is the absolute boredom they will evince. They will point out the Emperor Getty isn't wearing any clothes and what is dangling there on display is tiny and dull.

Like Bank of America, the Getty measures greatness in the current price tag of the objects from the recent past. The more money that something you touched in 1974 is worth now, the higher up you are on the *Pacific Standard Time* food chain. What the Getty is really banking on is your compliance with occupying the past instead of the present to enable their control of the future.

● November, 2011

Mystery Museum Insists It Be Ignored

On Saturday I was at a reception for an art exhibit at a local cultural institution. A big show for a good artist who deserved it. A great crowd. Festive, exciting. In my mind I thought of some ideas for an article about the artist, the venue and the show. I could have taken 150 photos of people there I knew on a first name basis and another 200 of their equally important companions whose names I had forgotten.

But a volunteer for the museum approached me and insisted that I stop taking photographs. I complied with his ludicrous sanction but a friend who witnessed the exchange posted a picture of Javier Bardem as Anton Chigur in *No Country For Old Men* on my FB Wall later saying that is what I looked like at the moment of the confrontation.

What sense on earth does it make for a policy like this to be in place? Why would an institution forbid photography?

Oh, there is the bugaboo about copyright and collectors lending artwork to an exhibition under numerous conditions, one of which might be that the work not be reproduced in a particular manner. Nobody is going to set up high-end cameras on tripods and reproduce the art for tee shirts. There is no copyright issue. Collectors who make demands about the work being photographed do not have legal rights to the images of the art they own; those rights are retained by the artist.

There is the old saw that the flash from the camera has an adverse effect on the actual art object. This is true only for some printed photography in unshielded frames. Many galleries have personnel explain that they permit non-flash photography.

Nobody at this event was bent on documenting the art. This was a huge party in the museum. To insist that there be no photography at a party is downright pretentious.

Museum volunteers and security were better off monitoring this massive crowd from harming the art, as wine-happy revelers bumping into pedestals and vitrines, leaving thumb marks on clean walls and frames would seem to be a literally pressing priority. But for some reason it was more important to make sure that none of the guests had a "Kodak Moment" that night. If an institution has misplaced priorities that serve a bizarre self-image as some sort of hallowed cathedral, that institution may as well go the full route of religion and at least offer all of us life after death as the reward for being so penitent in their presence and submissive to their self-flattering whims.

Perhaps there are more nefarious reasons for forbidding photography at public receptions. Would an absurd policy like this be more likely to emanate from a board of trustees with things to hide? If the priority at public events is in hiding things from public view and maintaining strict control of how the inside of the institution is viewed, it is not a stretch of the imagination to speculate that people in control of this institution have things to hide. Are there two sets of accounting books? Are subcontractors overpaid on invoices specifically to kick back a portion of their payment to the party who approved the expenditure? If your museum is hell bent on stopping me from taking a party pic of three artists toasting your exhibition, I will freely speculate about your fear of transparency.

Finally though, we are left asking what the role of the museum is in the 21st century. If truth is the last casualty of the grant process, imagine the accuracy of this application for funding:

"Our museum works hard to ensure that no record

of our events is ever allowed to be documented or disseminated without our express, written consent. Please give us grant money to hermetically seal all evidence that our exhibits ever took place. Your patronage will assure that in addition to presenting the art of our time, nobody will ever see it, enjoy it or know about it. Be assured that your grant money will especially prevent anyone ever getting tagged in an unauthorized uploaded photo having fun in its presence."

The dollars should flow in, right?

• September, 2011

What Artists Need to Know About Gallerists Staying Current

I made the leap from critic to curator, but not from writer to non-writer. My decision to open a contemporary art gallery in Los Angeles was as much a case of cabin fever as it was a love of putting art shows together. There is plenty to write about on this adventure through the inner workings of it all. Please join me...

We had our big opening party on a Saturday, but Wednesday was my first real day at work. After about two hours at the gallery something dawned on me: I would not be getting out much. The gallery is going to take four weekdays. That leaves three days to go out and see anything. The other galleries in town are closed Sunday and Monday and plenty of them are closed on Tuesday as well.

Studio visits? Where will the time come from? Artists should know that gallerists probably don't get out and stay current. Sure, some have directors and assistants, but all too often those same job-creators have other lifestyle priorities than getting their shoes dirty on the studio visit pavement.

For years, I made a game of asking gallerists at Culver City and Bergamot if they had seen a great show at a nearby gallery, one less than a hundred feet from their front doors. Almost never did the gallery director answer in the affirmative. There I was, walking by six neighboring galleries on the same Chinatown row of shops as mine, and I just didn't have the time to take a gander at a one. The game had come for me.

What does it mean for artists that the person who has the power to grant you a career-changing solo show

doesn't get out and keep current? Oh, there are always a hundred excuses, most centering on being too busy, but gaps develop—gallery power brokers are not filling in these information gaps on their own.

This means that the art media and the people who have the ears of the gallery leaseholders are their eyeballs, their vetters, their next big gamble.

So here's a lesson for you all: coverage in the art media is doubly important because gallery owners will stop and read an art magazine or surf the art news websites. Gallery owners will listen to the recommendations of their close friends, confidants and collectors. There isn't really any other efficient method out there. Yes, I'll get by with a little help from my friends.

• April, 2012

Why Art Critics Really Hate Art Fairs

Suddenly the essays decrying art fairs appeared out of nowhere, a tsunami of scolding. Every time the term "art fair" was mentioned in an online or print essay, some embittered art critic was picking apart the art fair establishment in mock horror. Art critics reflexively hate art fairs. Art critics love solo shows, surveys, retrospectives and group shows. They love them all because these shows need the validation of a review. Art critics have no place at an art fair. They are not there to buy; if you're not at an art fair to buy, you're probably in the way.

When you read another curt dismissal of the "whole state of affairs" surrounding art fairs, understand that art critics are usually smothered in false adoration and undeserved attention from the art world in the hope of a good review. Art fairs barely get around to printing up a press pass for them because a review after the fact is worthless. Imagine a review of Macy's Labor Day Sale during their Thanksgiving Day Parade.

A life of endless daily stroking to "come see our latest show" leads Mister or Ms Critic to assume that his or her opinion drives culture. Suddenly an art fair gauntlet of cold shoulders at booth after booth meets the progeny of Vasari. Art dealers and collectors are there to work with each other and the hoi polloi are there to fill space and drink free champagne. No factors surrounding the art at art fairs involve a "latest show" review. Therefore, an art critic walks into an art fair and they are back to being the nobody they were the day they picked up their poison pen in the first place. The art fair is never going to get a fair shake after so shaking up the order of the art critic's world.

If you are not at the art fair to buy, you'd better at least look good and give the fair some buzz and make it easier for people to sell art. Art critics as a rule do not buy art and do not look good. So most analytical writing about art fairs by art critics is the equivalent of a eunuch penning a review of surgical scalpels. Critics see their purpose as somewhat akin to a priestly mediator between the art experience and the true believing audience. But one context size does not fit all, Mr./Ms Intermediary; plenty of art collectors and enthusiasts enjoy art outside the sacred temple gallery exhibit context. It is the limited thinking of art critics that cannot imagine art outside of this one arena that begets dismissals of art fairs. It is sad that unchecked envy reveals such limitations.

Art fairs are a combination of museum aesthetics, swap meet dawdling and the Antique Roadshow assurance that one specific object has a valuable pedigree. As predictable as a sunrise, art critics pull one last aspersion from their bag of tricks when addressing art fairs. They dismiss the marriage of art and money. Why do critics do this? Art critics don't get paid a living wage. They don't know anything about money. Art dealers know about money; they do the job of the critic when they hire a curator or pick the art themselves. They know what each piece must sell for.

Art dealers are the shopkeepers, a hint of glamour and the possibility of immortality among the inventory in their crates are the only things that separate art dealers from a Subway sandwich franchisee. You buy the sandwich you think you are going to like and the collector buys the art they think they are going to like. You don't need a professional sandwich critic to explain the postmodern implications of that turkey club you are going to order and art fairs don't need critics to deconstruct the juxtaposition of differing materials among the artists in their Basel booth.

It is time art critics hold the mustard; they are hot-dogging on the wrong bun when they bash fairs. The way things work these days, without art fairs there wouldn't be an interwoven, complex assortment of international fine art galleries that comprise the art world. Art fairs remind art critics that it is almost charity that their avocations exist at all.

• May, 2012

The Art Collector Youth Fixation Factor

The art world discriminates based on age. I would advise every artist reading this to immediately remove your birth year from your website, from your Facebook page, from your CV/Resume. Oh sure, you strident few might squeal, "but I'm proud of my age." Well, power to you, Gramps. Art collectors have the vampire gene and one reason they are even collecting art in the first place is to suck up the energy of young blood. So be proud of being a boomer and never get your art shown or sold.

Is it wrong of a collector to want to know the age of the artist when they buy an artwork? Let's wish to see the day when there is a simple answer to that question. If you had asked me before I opened an art gallery, I might have said "of course." But after encountering this query a number of times, it just isn't so simple. Now I realize the depths of this ugly streak. Once an art collector is old enough to be a grandparent, he or she just will not buy the work of artists who would not make good breeding partners. It is a psychological compensation issue and it rules what artists galleries select. If you weren't born in the 1980s, you are too old for most trendy collectors, most of whom are the über-vain remnants of American youth culture's heyday circa 1959.

Of course it is a delusion on the part of collectors that the age of the artist is of consequence. One out of a hundred artists uses culturally specific references to a degree that the context of the artist's age informs the viewer. A collage with a picture of Johnny Rotten made in the year 2012 can mean very different things if the artist

who constructed it is 51 years old or 21 years old. This is the exception. The age of the artist hardly ever matters relative to the subject matter of the work, and usually it would be the work of historians decades later to determine such contexts.

But that doesn't stop insipid picture-hoarders from inquiring about the age of the artist as they stroll through the gallery. And they don't ask for the artist's age in a tactful manner. Oh no; today's collectors examine an artwork and, mildly interested, the look on their faces changes into a look of lust as they ask something like "Is he young?" or "Is she fresh out of school?" In response to this question from a collector recently, I meant to say that an artist was 31 but it just slipped out, "Oh, he's 21, just out of art school," and the collector had a spontaneous orgasm right in front of me. Art galleries are a lot like internet dating—people prefer to hook up with hot young single catches and collectors prefer to buy hot young artists. Most generation gap flings don't turn into serious relationships and most twenty something art purchases don't increase in value. But their lust for young blood coupled with that fear of their own creeping mortality makes collectors reflexively ask the stupid question that only makes them look more desperate, "Do you mostly show young artists?" ...so to close this sale, am I supposed to reply "Oh yeah, I wouldn't dare show any artist who is even half your age."

Once they have had a few young conquests (aka bought some art by artists in their twenties), collectors are a bit more demure, but they are just as desperate for young flesh via canvas. They ask trick questions. Asking whether this is the artist's first solo show can often be a roundabout method for a decaying old collector to not telegraph his youth-obsessed neuroses. If a curator is able to recite a litany of group shows to bolster the pedigree of the artist,

the good faith effort has actually killed the potential sale. Most art dealers are behind in learning trendy collector math: Artist With Experience = Past One's Prime.

Savvy collectors try to find out about an artist's education, not because the collectors are impressed with student loan diploma mills and art theory classes taught by has-been art writers, but to unearth the true age of an artist. Knowing the year an artist graduated can have the power of ending your career as if it were engraved on your tombstone. Today's trendy collectors are so caught up in making sure they don't buy the art of a body that has seen thirty years that they miss a pretty glaring problem when they bring up art schools at all: art school MFA programs are run by the fuddy-duddiest old artists in the land of old artists. Impressionable young kids make art that parrots Gramma's Masters Degree kitchen. So instead of buying the art of has-been art school professors, collectors think the hip young imitations of the professors are going to be valuable in a decade or even interesting next year. Maybe someone needs a degree in collecting art before they call themselves a collector.

The desire for young artists is not well thought out. It is emotional. Collectors age at the same one-day-at-a-time rate as you and I. They delude themselves, though, that they are staying young by buying young and rationalize it with hilarious justifications. One collector told me she needed to buy young artists because she wants to be able to follow their careers. Honey, you're going to be in diapers if you make it to the 45th birthday of some of these new art school grads, have you thought about that? Nope, you have not, because no rational approach to collecting current art could argue on behalf of considering the artists' youth as a factor.

But nobody confronts collectors, no matter how pathetic their palpable fear of appearing aged and out

of touch becomes. Artists grow meek in their presence. Galleries just sell to them. No matter how tragic their incapacity for self-awareness may be the only antidote for collector's youth fixation is for galleries to have plausible deniability. If the artist is not standing between me and a collector, my recollection of working with them is that the artist is "...oh, about 26, maybe 27. You know Basquiat was 27 when he died and his prices went through the roof." That turns every collector on!

If the artist has no age listed anywhere, no references to any dates, no shows listed with a date more than three years old, no mention of the year they got an art degree or if they studied with some fossil professor who is almost as old as the average art collector—the artist can actually protect the collector from his or her self. That noxious need to equate hip with young is a product of 1950s and 60s Americana and the old folks who learned it then have carried it to this day. But all of us younger, but not too young, art folk can let the quaint notions of yesteryear warm the hearts of the aging American collector base by flat out lying to them when they ask idiotic questions about artists that have no relevance to the art we are trying to sell to them.

● June, 2012

Art Fair Pests Are Everyone's Problem

There were a hundred booths at the art fair and I could see this one guy walk into each one and leave with a spiteful look upon his face. He stuck out in a crowd, though, and an art fair crowd is one where every other person is desperately trying to stick out, be it through lavish jewelry, foot-torturing shoes or hairstyles that look like they are applied as animation cells.

What did this character do to stick out? Well, he was carrying a framed painting. At these affairs, many people are scurrying about with art in hand—often bubble-wrapped with a SOLD tag on it or coming out of the fair's on-site storage to replace sold work, the blue collar art handlers weaving their way thru the crowds with ease, swiftly hauling around large pictures that would cause anyone else to break a sweat after ten steps.

This guy, though, was different. He was cuddling this painting. Despite his schlocky fedora/sportscoat attempt at "dressing-up-yet-standing-out" he looked like a complete nut. Of course, the myth that artists are magical beings who are different than ordinary people gave him his bold righteousness. As he entered the fair booth next to mine I could see the look on his face. It was one that some might call determination. Others, though, might have seen anger and bitterness posing as resolve. That painting he clung to was like a lifeline, it was as if it was attached to a helicopter and he were hanging on to it for dear life.

Yep, he was an artist. Let's ignore the actual quality/content/intent of the painting to which he clung. It wasn't my cup of tea but you can imagine if you would like that it

was a masterpiece. Because as much as he wanted it to be, the encounter that this story is leading up to is not about his art. And it is not even about him. It isn't about me, either. So the only one left for this tale to be about is YOU.

This man was walking around the art fair and belligerently confronting art dealers. Imagine if YOUR art was on the wall of a booth at the fair. A big collector walks by and is intrigued. Usually that is my cue to sell YOUR art to the buyer. But the Frame-Cuddler has me cornered in the booth, asking if I like his art, explaining why he thinks it would be great for my gallery and generally preventing me from moving away from this imposed conversation.

The collector lingers, looking at YOUR art while I tell the pest/artist I am not interested in his art. I am not polite but all it does is make him bolder. He starts to tell me I need to be educated to understand why he is a giant of art. The chance for me to sell YOUR art is ticking away, the seconds are like hours as I somehow look left and weave right, breaking free from the pest and his picture and turn to make my way across my gallery's art fair booth to the buyer, but oh... my charge forward is only to see the back of their designer clothing walking away... away from your art, away from my gallery's booth and on into to the fog that is the rest of the art fair.

The pest just moves on to another gallery across the aisle. His work is done. He ruined my sale. He ruined YOUR sale. And yet, somehow, some way, he remains the underdog and many casual observers will root for him. There is a romance in his narcissism, a dream to embrace in the casual glances of people-watchers. Something about his pathetic visage inspires everyone. Well, everyone but me... and hopefully now, YOU.

<p style="text-align:right">● December, 2013</p>

The Career Benefits of Boycotting Charity Art Auctions

There is a tradition of auctioning original works of art donated by artists to raise money for charitable causes. There are many good causes that hold such events. No matter how good the causes, though, I have come to the conclusion that artists must stop donating to every single one of them.

Don't ever donate your art to a charity auction again. Half a century of charity art auctions have changed the way collectors buy art. These fundraisers have depressed prices of art across the board and kept artists in a subordinate position that has no career upside or benefits.

Instead of tossing away another great artwork to a good cause, join the good cause of boycotting charity art auctions. When you join this cause ...

- You stop taking revenue out of the art world.
- You stop shifting art collector dollars to the bottomless pits of recurring annual Beg-A-Thons.
- You don't contextualize your art as being a synonym of pretentious panhandling.
- You don't announce that your art is worth low bids.
- You don't risk that your work will be publicly seen getting no bids.
- You don't empower strangers to devalue your artwork.
- Most importantly, you stop publicly proclaiming that you give your art away.

The argument against me is simple: Donations of art to charity auctions raise money for good causes and raise the profile of artists who put their art in the public eye. It is a good argument. It has worked well. This seductive sales pitch has pulled in countless millions of dollars over the past few decades.

Problem is, this argument has not lived up to its bargain. Sad news: Your profile got humiliated because the collector got such a bargain on your art. If your art was one of dozens of trinkets on a wall with a hundred other artists, your profile actually disappeared there in the crowd anyway.

I would love to hear the story of the artist whose career rocketed to success because he or she donated a work to a charity auction and this act alone tipped the first domino toward an avalanche of success coming his or her way. This narrative is always implied. I've never seen it happen.

Charity art auctions are the emptiest of promises to artists: you give us your work, you get nothing in return except a party invite to an event where you are a second class citizen. Watch as the price of what you really will let your work go for is nakedly advertised to the select group of people to whom your work is meant to be seen as rare and desirable.

Suppose you want to at least deduct a donation of your art to the charity, guess what? The law only allows an artist to deduct the cost of materials. Meanwhile a collector can buy your work for the minimum bid, have it appraised at its full retail value and donate it to some other good cause for that top dollar amount.

As for the merits of the infinite number of good causes out there, what is the value in giving up a painting that would sell for a thousand dollars retail in order to see it raise fifty bucks for that cause? Pick one charity, donate

generously and keep the collectors assuming that the price you ask at the gallery is the best and only price they are going to get.

Someone has to be the bad guy here, so you can blame me for inspiring you to donate cash to a good cause and to keep your art career safe from the bargain bin. Print this out and send it with your regrets to anyone asking you to devalue your work in the name of glamorizing their efforts on behalf of yet another worthy cause in a world of infinite and endless good causes. Tell them the art stops here.

● June, 2011

My Archives

I've got all these old magazines, newspapers, pamphlets, fliers, journals in my archives. I dreamt of having all these articles mentioning me when I was a kid. I saved it all. Boxes of yellowing paper, some slick glossies, lots of stuff.

There are five or six boxes in the garage. And I just started throwing it all out. This was not an act of self-destruction, no, but I did have to "check" myself in regards to what I was doing. Why was I doing this? Well the main reason is we just don't have the space for boxes overflowing with print magazines. It is just hoarding trash at this point. That isn't a sign of defeat. That is not giving up on my youthful vision of establishing a legacy. It feels awkward to have lugged some of this shit around for three decades and to then just toss it this late in the game.

But it dawned on me. If this vaunted dream of my youth is to mean anything, shouldn't it mean that it will be worth a researcher's time to track it all down? Either you are worth them doing the research on you or all the articles you saved were just a form of flattery. So there it all goes, into the dumpster; you gotta roll the dice with or without the rationalizations.

● June, 2013

Chapter Two

THE PUBLIC EYE

I could have called this chapter "Seventeen White Guys" but "Public Eye" sums up the breadth of ways in which celebrity collides with accomplishment to manifest as an impact on the audience—here that audience would be me. Reminiscing is, inevitably, a dangerous escape mechanism by which to avoid present and future by splashing the past upon oneself as if it were spring water from the fountain of youth. Like any drug, you wake up older and broke if you go in too deeply. I've thus learned to look back upon the sacred occasions—death, anniversary, and once in a lifetime confluences. But the public eye is blinking in the present too and the fascination with mass attention drove a few of these essays as well. And writing histories is, simply, a conceit that the future will embrace what we tell them we saw.

John Waters And Jeff Koons:
 A Chat to Nowhere50
Whitey, Arnold Carlson, 1924–201053
A Sketch of Dennis Hopper56
The Replacements.............................59
Happy 100th Birthday, Jackson Pollock..........61
The Fast Times and Faster Prose
 of Craig Stephens..........................64
Memories of Leonard Cohen Live67
The Impact of Lucian Freud72
Lou Reed—Don't Settle for Walking74
A Convergence of Four Art Critics78

John Waters and Jeff Koons: A Chat to Nowhere

Los Angeles turned out in force to see John Waters interview Jeff Koons at the Orpheum theater, part of a series of conversations sponsored by The Broad. Yes, The Broad Museum is being branded with a text-driven logo reading "THE BROAD" even though, and we were reminded of this, it doesn't open for another year. Scary stuff when a museum that doesn't yet exist can deliver two true superstars, pack the 2,000-seat capacity Orpheum theater downtown and assert its supremacy as L.A.'s institutional home of contemporary art. And Eli Broad was in the audience, as was a range of the creative class from Ed Ruscha to Mark Ryden; from curator turned dealer Paul Schimmel to a goateed Mark Mothersbaugh, along with a gaggle of L.A. art world glitterati mixed in with lots of celeb-magnets usually spotted at B-List Hollywood parties.

The two giants of bad taste were introduced with matter-of-fact fanfare and immediately got down to work. Waters was the interviewer, Koons the subject, and right away the impish film director tried to turn it into a therapy session by asking Koons where it all started. A compliant, pleasant subject, the artist immediately went into a tale of how his older sister did everything better than him until one day he made a drawing and his parents were impressed.

The first impression Koons gives is that of a relaxed, earnest salesman, pitching his listener on a product with assurances and certainty. He talked about being inspired to want more from life by listening to Led Zeppelin. Kashmir never seemed more bland. In his delivery, the person that

Koons most reminded me of was Mister Rogers and as the evening went on, he only got more "Hi Neighbor" with the audience. His veneer of cool sincerity never broke. And yet it was so saccharine that it seemed insincere. Having worked with actors for most of his life, this did not bother Waters at all.

Rather than trudge through the muck about Koons (the litigation, the child custody battles, leaving Gagosian gallery recently) Waters was never contentious. About as real as it got between the two was when Koons was discussing an artwork for a conical child's birthday party hat. He said he threw his son a one-and-a half-year birthday when he turned 18 months old and the child was abducted by his mother the next day. At one point John asked Jeff where ugliness fit into the work and Koons was utterly stumped, discussing how all people have a dark side that needs to be addressed the work; but even this "real" moment just seemed so rehearsed. Ever the film director, Waters practically asked him to read his lines again. Koons went deeper into a rehearsed sales pitch and never answered the question. He was oddly incapable of addressing ugliness or even acknowledging its existence.

When given the pulpit to expound on what his work was about, Koons delivered a pithy sermon about acceptance and ending judgment. It sounded sweet on the surface but consider what he was saying: Ending judgment means ending critical thinking. Acceptance means liking whatever you are being given. The man's core message is a riff on blind consumerism and has an undertone of anti-intellectualism far more sinister than your average violent anarchist. Just what the billionaire art collector ordered!

With plenty of opportunities to mock or harass his guest, John Waters stayed the epitome of a gentleman, if perhaps a little too fawning. But it was never awkward and

the hilarious asides by Waters were worth the $20 price of admission. Discussing his youth, Waters said "I was drilled on the rules of good taste, and made a career out of rebelling from it." Discussing a trip to the Baltimore Museum of Art where he bought a print of a Miró painting and hung it in his room, the negative reaction by all his young friends emboldened the young Waters to appreciate the power of art to upset and enrage people.

But the line that got the biggest applause from the quasi-elitist crowd was when Waters stated firmly "I think that art for the people is a TERRIBLE idea." This was, sadly, the only real retort to the canned populism of the wooden Koons, who had rattled off a series of platitudes about how all the rich people buying his art meant that the art was usually free to see in the museum and how great it was for all people to experience it for free.

While his host Eli Broad was certainly flattered, the howls for that John Waters comeback let everyone know the loyalties and aspirations of the L.A. art world. While Koons asserted that he was not ashamed of his middle class roots to the point of never breaking character, Waters was our collective id, equal parts repulsed by the tchotchkes of American life but indulgent in the power of their ugliness. The Koons schtick was not to be believed but it was made bearable by the wonderful Waters, equal parts jaded and amused... and, in the end, probably relieved that Koons was as synthetic as imagined.

• February, 2014

Whitey, Arnold Carlson, 1924-2010

Whitey Carlson passed away a week ago. He founded the Brewery Art Colony along with his two sons. The day I walked into the Brewery Office to sign a lease I was wearing a tee-shirt I bought at a thrift store and it had a cover of the Saturday Evening Post painted by Norman Rockwell. I wore it to be ironic, but Whitey got excited when he saw it while I was going over the lease paperwork. He told me about his first job—selling the *Saturday Evening Post* on the street corner. I asked him how old he was, he said "Seven."

SEVEN YEARS OLD? Yes. Seven. On a street corner in New York in the dead of winter.

You could never have a conversation with Whitey and not be reminded that it is a much different world than it used to be. He had stories that were so surreal they could only be true.

He was throwing craps in a casino in Cuba run by Meyer Lansky—the famous gangster stopped the game and asked the young Whitey (throwing dice on a hot streak), "how do I know you, you look familiar." Whitey said: "I'm from Long Island, your mother sent me, she said you don't visit enough." Everyone had a great laugh and Lansky made sure Whitey and his friends were taken care of with everything they wanted. Whitey was no bullshit, no finesse and no backing down. Kinda like America used to be.

Whitey ran a circus, he told me the most important thing to running a circus: "You gotta have an elephant. You can get away with not having anything else, no clowns, no trapeze, no ringmaster even, but if there ain't an elephant, people want their money back because it's not a circus without an elephant." It made me reflect on things—what is the core thing you gotta have to do the thing with which

you want to engage the public. What is the elephant in your circus?

I ran into a woman who was from Whitey's generation. She told me she was from Long Island, grew up there, still lived there. I thought I would impress her. "I know the man who once owned the Long Island Coliseum," I told her. She was not impressed, scoffing "Well your friend probably paid too much when he bought it from my friend, Whitey Carlson." Anyone who knew Whitey at all knew he was a shrewd businessman. He told me about booking extra security for a 1970 heavy metal concert at the coliseum. He believed in plainclothes security beating rowdy patrons as a way to settle down problems before they escalated. But there is no shortage of Whitey stories, great tales, and I am way down the list of having known him. When he would see me in the parking lot at the Brewery he would always ask: "What is your business here?" I would tell him I was a tenant and then he would lighten up and have no trouble spinning yarns from a bygone era of hard work and freedom.

It was an era where nobody helped you, and so you had to learn to help yourself. He was protective of his own property—when a guerilla rave promoter took over the largest building at the Brewery—the empty Bingo smokestack building—Whitey slammed the large doors shut and pulled his truck in front of them—locking in a thousand-plus ravers who panicked and tried to climb out windows as the cops pulled up. Another time a different underground rave promoter had the supplies for the whole Saturday night dropped off at the unattended building on Saturday morning. Whitey filled two storage containers with generators, lighting equipment and booze.

A book could be written with the best Whitey stories. When he overheard a discussion in the Brewery office

centering on horoscopes he interrupted. "Is this talk about faeries and spirits?" he asked. We all half-heartedly acknowledged that it could be seen that way. He then asked, "Do you believe in the hereafter?" to which nobody wanted to commit an affirmation or not to him. Finally I said "Sure" and he smiled, "Forget about the hereafter. Take my advice and from here-on-after keep your wallet in your front pocket."

Well Whitey, the hereafter has come for you, but as I write this, my wallet is in my front pocket. Thanks.

If the plethora of stories about his life that need no exaggeration to be fantastic are not legacy enough, having a hand in establishing the Brewery Art Colony most certainly is.

● August, 2010

A Sketch of Dennis Hopper

Most everyone has a Dennis Hopper story. Even if you never met him, your story of how a character he portrayed expanded your consciousness is right there for the telling. Over the years I had heard two different firsthand versions about who Dennis Hopper was relative to his interaction with the art world. The first was an older artist who complained that Hopper was always there to pat you on the back when you were riding high, always looking to co-star in whatever spotlight you were enjoying, and was guaranteed to be off looking for other spotlights and high riders in the right place when the glimmer of success had faded away from you and your career. This painter may as well have brushed "Hollywood Phony" on an *Easy Rider* poster, so blunt and vivid was his rebuke to Hopper being just a celebrity seeking the serious status that only the art world sees to be able to bestow.

Well I relayed this description to another early 60s art veteran. He said it only rang true if you looked at everyone else of Hopper's level of success. Look at anyone who has been successful in Hollywood and notice the pattern of constantly seeking out the right place and "right people"— it is so easy to spot, because it is downright common. It is a behavior pattern that is repeated at every level of success in the industry. "And in the art world too..." he noted. In defense of Dennis, this legitimate beatnik assured me that Hopper had spent time in the mid-to-late-50s counterculture scene on the west coast when it was comprised of less than a hundred people. He rattled off a list of experimental poetry readings, beat coffee bars and radical art events that were hallmarks of a time when to be

different was dangerous. And he vouched for Dennis being there as a participant, not just an observer. As far as he was concerned, Dennis had earned his stripes and could not be seen by history as a mere interloper no matter how far the magnitude of his success and celebrity may have catapulted away from that short era of authenticity.

Sometime in the mid 90s I was introduced to Hopper at the old Kohn Turner space during a show of Bruce Connor's work. Dean Stockwell and I had been chatting and up walked Dennis. Stockwell took great pleasure in telling Dennis that my criticism could (theoretically of course) cut a hole right through him or any artist. Dennis just smiled and shook my hand, asking "So the pen is mightier than the sword, but can it do battle with art?" He stared in. It was the sponge of the actor. Thespians provoke in order to sop up what you give them. But I was not being presented with a game of checkers here. Hopper was working on at least two levels. He had taken photos on Hollywood back lots and green rooms with an access no fine art photographer or journalist ever had. The results were both journalistic documentation and artistic photographic renderings of what was to be perceived: less critical than Robert Frank's *The Americans* and less tragic than WeeGee's oeuvre. They still fit in seamlessly with the midcentury transition of photography capturing the real as hyper-real. He was acting in movies and carving a fine art photography niche that nobody else could have. Thirty-five years later he was provoking me in order to hone his own professional craft while he engaged in a cocktail party conceptual challenge.

So the game was on. "The pen can be the pedestal for art, but it can also be the stake through its heart," I said.

"Who said that?" he asked.

"I did. Just now." He looked at me incredulously,

smirked and said, "Well ... you're right!"

Then he put his arm on Dean's shoulder and led him away to begin a new conversation with his old friend. The whole thirty seconds had confirmed the two conflicting descriptions I had heard about him. He wanted to get right to the essence of the right people and he had an authentic hunger for the core creative kernel; and if a work of art cannot have two conflicting meanings coexisting in permanent glorious unease, then it cannot be a great work of art.

So I will not hesitate to affirm my belief that Dennis Hopper was a work of art, perpetually and insatiably seeking to possess multiple meanings and cash them in to indulge in every experience under the sun.

● May, 2010

The Replacements

Everyone is at Coachella seeing the reunited version of The Replacements. Everybody but me. But I am here listening to everything they ever did and you know how nostalgia is the sweetest poison, right, don't you?

I never saw them live and didn't own any of their albums until well into the 1990s but there were friends who when I would visit I would just walk up to the record player or the cassette player or the CD player and put on whatever Replacements record I could find. And it was always sublime and nobody ever walked over and put anything else on.

They were controversial. Every rock critic was rooting them on and they got more press, more worshipful press, than any band I can recall, but they did their own thing and were self-destructive, career-sabotaging, actually often dumb and in hindsight perfectly reasonable; refusing to make videos and then making videos that emphasized anti-stardom (along with the Pixies) they had this same retrograde stubbornness, they would not play to the camera—and this is in the day and age when even Bob Dylan was sucking in his pride and lip-synching to the glam camera, MTV being seen as the only way IN and the Replacements shrugging their way out.

Their live shows had all sorts of stories about how fucked up they were. Never sober, often one member too incoherent. And yet there was magic as it was told to me by those who had gone. Like them I was just too fucked up to get it together to dance with Ticketmaster.

And the howls of bitter anger from so many corners when they named that album Let It Be. One of the great

shit-stirrings of all time.

But seriously, I recall where I was and who was in the room and how bright the lights were the first time I heard Alex Chilton. I remember the color of the carpet and the shape of the wine stain nearest my hand as I listened. I've been in L.A. so long that every damn intersection has a memory and there are streets that call up their music clearly and some blocks in town that I am almost high again on something I drank almost thirty years ago as the memory is more alive and real than the consciousness of the present driving by... and when it is that buzzed, sloppy and soul-consumingly expansive, that thing that is the replacement of stasis is, yes, The Replacements. I'm in love with those songs.

• April, 2014

Happy 100th Birthday, Jackson Pollock

Happy Birthday, Jackson Pollock. The most controversial artist of the 20th century was born one hundred years ago on January 28, 1912 in Cody, Wyoming.

Pollock remains a polarizing figure in art and culture, for all the right reasons.

He is roundly derided on each plateau of society for his poured allover paintings of the late 1940s and early 1950s. From Joe Six-Pack claiming that his third grade daughter could do just as good to post-modern scholars deriding the assertion that the arts can contain a singular heroic act, many can meet and agree that Pollock is overrated while sharing no other cultural attitudes in common. Feminists scold the complex relationship he maintained with his wife, the painter Lee Krasner, and the entire Pop Art and Pop Surrealist movements seem predicated simply to stand in opposition to what Jackson Pollock created. The acquisition of his pictures with public funds by museums has ended many a political career over the past fifty-plus years.

If you can measure a man by his enemies, Pollock makes Picasso and Warhol look like lovingly muddied mediocrities. Years ago I wanted to get one of Pollock's artworks as a tattoo. In searching over his catalog raisonnè I could find no image that was adequately recognizable when reproduced as an illustration in ink. This is quite an accomplishment for any artist, especially one whose work

before and after his poured paintings emphasized the same literal black line that is the formal basis of traditional and modern tattooing. I had to settle for a rendition of the famous Hans Namuth picture of the artist stretched out over his canvas, the bucket of paint in one hand pulled back as the arm stretched forward with a primitive stick coated in chroma.

The tattooist, Mike Horton, asked me at the time if there should be spattered paint under the drawing of Pollock or perhaps flinging off the stick into space. No, I insisted. I had come to understand all too well that the power of Jackson Pollock as a symbol had far outpaced the majesty of his glorious pictures, be they the infamous allovers, the 1940s expressionistic masterpieces or the rambling late work's fertile search for a reacquaintance with form.

And so, 16 years after getting that ink, I still goad people into the conversation of who their favorite artist is. So few ever give a definitive response. Art world denizens hem and haw and meander as if reciting their recollection of last year's *ArtForum* cover children. LowBrow etiquette demands a nod to the outlaw roots of the movement and an inevitable capitulation to the most dexterous realist to grace the inside of last month's issue of *Hi-Fructose*. Street art fanatics get quite "undergrad thesis" these days about the origins of Blek Le Rat and tagger names that exist only in legend. Philistines insist that media is art and the astute ones rightly choose Matt Groening over Spielberg as the greatest living artist. Sanctimonious stiffs insist there hasn't been a great artist since Raphael. Nobody ever says Thomas Kinkade, the squarest of souls having long got the memo that the painter of light is dreadful. When they

return the question, I just pull up my sleeve; if you gotta ask, as they say, you'll never know.

Happy Birthday, Jackson Pollock, you did more in your forty four years on earth and the fifty six since than almost any artist: you made people think and talk about the process of making pictures without ever involving yourself in process or conceptual art.

●January, 2012

The Fast Times and Faster Prose of Craig Stephens

Craig Stephens was a freelance writer émigré from Australia who looked like he might have been the byproduct of a good-looking groupie and Paul McCartney—and that was the first thing I said to him when I met him at Barbara's Bar at the Brewery Art Colony in 1999 or 2000 orwell like everything whirling around Craig there was a blurry edge on all of it, every night, dimly lit, late past 1 A.M., cocktail in hand, a girl way too good-looking to be with a bum like him tugging at his waist, a friend or two running out for who knows what, an acquaintance running in to explain where the better party than this one was.

He took the McCartney jab with a curious sizing-up of who the hell would say such a thing but also had a good laugh—I liked his thick skin, his ability to have shit shoveled up to his waist and to just crawl out of it and head to the next happy hour.

That first night he didn't tip Howard the Bartender after dropping a hundred bucks or so on cocktails for him and three friends—a fat guy along for the ride who had never left home but was probably the guy they got a ride from and two hot girls grinding their teeth as they sneered about American culture with thick, rude Aussie accents that forced Craig to pull up close to me and apologize "They're kinda like the Aussie equivalent of hillbillies, don't let it get you mad."

Howard was enraged when he sees the credit card slip with no tip and walks out from behind the bar and starts to give the "Down Under" contingent a lecture on the custom of tipping. They play dumber than rocks but Howard had paid enough attention to the conversation to point out that Craig had been here two years and had to know the custom. Howard followed the crew to the parking lot, barking like a hyena and came back in broken like a Chihuahua—all Craig had given him was that McCartneyesque smile and while it worked for the lines of aspiring actresses, supermodels, rock and roll front women and art tart starlets, it made Howard grumpy when it was all he got for pushing a hundred bucks worth of the sauce that night.

I brought up that story to Craig years later. He was a bit sheepish copping to it, but I told him a hustle here and there was often necessary. "Here and there? How about every day in this town!" and the expat angst was revealed from behind the smile, the journalistic detachment, the joint to take the edge off of the rent being due. He hustled gigs writing all sorts of stories, a pile of clippings that span a range of interests from the highest perches of art to the lowest dregs of cultural desperation. He was not a depraved soul but he traded in poking at the glow around that soul to share with his readers what that light reflected.

He wrote for anyone who paid about anything they cared to have covered and he blasted out the prose to make sure the customer was as satisfied as the reader would be intrigued. Like the hearts he broke, he burned it bright and then freelanced on down the road to follow the next perfect-bound piper.

Craig died about a week ago. He had emailed me about some heart trouble. It sounded treatable, but apparently was much worse. On FaceBook they say his mother and sister are flying in from Australia today. Oh my deep condolences—but please know that your son lived five, maybe fifteen whole lifetimes in Los Angeles, he died an Aussie Angeleno aged 120. There were few corners of this part of the globe he didn't have a wild story best preserved as a Polaroid about.

I hope they find an organized assembly of what he wrote, it would be a diary of getting the 21st Century's Hollywood party started.

● December, 2013

Memories of Leonard Cohen Live

I have seen Leonard Cohen in concert three times.

#1. "Like a bird on a wire, like a drunk in a midnight choir, I have tried, in my way, to be free"
 I drank a lot of Jack Daniel's and Coke on the afternoon of what would be my first time seeing Leonard Cohen—it was at the Wiltern Theater in the late 1980s. A bunch of us went. Tom Tyson was the cat who turned me onto LC and he was the one who got us tickets and he was the one shaking me passed out at 6 PM saying to get up, get ready, let's go.
 There were plenty of Coke cans at his place to drink, all with enough caffeine as out with the group I went. When we walked up to the entrance I was halfway thru a can of Coke knowing they were going to make me throw it away but if there was one thing I was intent on doing (back when I drank and to a lesser extent even today) when confronted by minimum wage security—it was in making a scene.
 So as I am walking into the Wiltern one guy then another then a lady and then some other guy all were politely saying "Sir Sir Sir" and panicking over that Coke can, I milked it to get about eight steps into the massive Art Deco Lobby and turned. You see by stopping and turning I had de-escalated the situation because they were going to be able to address me without racing after me any longer or physically stopping me, but as I was about 45 degrees into my 180 degree turn I began belting out a missive...
 "Ah fuck, Tom they're all fucking yuppies in here"
 In case you are wondering—the lobby of the Wiltern has an amplification when one shouts aimed upward at the

rising ceiling. Every yuppie with good taste in music within ten feet of the entrance and all those who had already made it inside heard my indictment. Every employee who had been chasing me for my can of Coca Cola had abandoned the front lines of ticket taking—it was me and them and a horde of people waiting at the gate—including Tom and the rest of the Starvin' Band and various other minstrels, outcasts and vagabonds who tagged along on those buzz-seeking weekends of the late 1980s. I'm loaded enough to be enjoying this and thespian enough not to smirk as I perfectly time looking at the security chick who just took a breath to tell me that I cannot bring my can of soda into the theater and ask her "Where can I dump this?" The four of them look at each other as the space around us is now empty—there are hundreds of people in the Wiltern headed to their seats and hundreds more waiting to get in and there is an island in the middle—me with three ticket takers, a security guard and a can of Coke. I follow up quickly to the ticket taker "Is there a trash in here?"

It is the deepest advice I can ever confer on you to never speak precisely when dealing with anyone who is on the clock. If I had said "Is there a trash CAN in here?" it would have been insulting to associate their job with garbage. If I had asked "Where can I throw this away" it would have implied that they were hired to think for me. The subtext of saying it the way I did was to underscore that there would not have been this situation at all if there were obvious receptacles at the entrance. By asking it that way, I was blaming the Wiltern—their employer. I had caused a scene and put it all on the man. I was wearing a white dress shirt with no tee shirt under it and it was only buttoned on two buttons at the belly and belt. One of them took my can and soon the flow of fans trickled up to me.

We sat in the highest rafters of that place. Leonard played "Avalanche" and it was as powerful as Christ reciting the Beatitudes. The rest of it blurs but the memory stands, longing for the four sips of cola left in that can.

#2. "I'm standing on a ledge and your fine spider web is fastening my ankle to a stone."

Years later, early 1994 to be exact, I am newly sober and working to extract myself from this codependent mulatta trustafarian Los Feliz musician and she is nagging me about some shit—it was weird, I quit getting loaded and all she did was turn on the nag amplifier—and I tell her I am going to go to the Wiltern and try to buy a scalped ticket to Leonard Cohen. Well she couldn't give two shits about LC because her snotty aesthetic was her master, but she can't let go of the leash that easy so we traipse over there, outside and see the lines and I'm actually ready to give up, they were ridiculously around the block and the scalpers wanted way more dough than those days afforded me.

But she is all of a sudden seeing musicians there that she knows from the scene, probably had fucked them all, and all of a sudden she is too damn down to turn around and, well to her credit, to her tenacious rotten soul's credit, she finagles someone she knows to pull out two extra tickets they are holding for someone else and suddenly we are sitting in the eleventh row on the floor, wow we have come a long way, and I know I am about to go a long way away from her to something more like this, the sobriety is clearing my head and Leonard's words were nice like knives of what one might dodge but now they are tools to carve out a space of my own. And she doesn't know anything or get anything but she sure loves it when the guys from the clubs come over to say hello to her. And I don't even look

up or sneer, I already know I am bailing but some things need an exit strategy.

And the lights dim and the wandering jew himself comes out—and it is nice to be close and the show adds years to my soul and screams that life is worth living and I stock up on those tools and that deeper understanding of existence in a ninety minute stage show and he comes back for an encore and the bitch says "we have to leave." Yeah, there was always a pressing reason to manipulate the world to one she could control with extreme prejudice and ever more some drama following her to make it sloppy and plenty of blame for me for sticking around, but this was indicative of one reason getting squeaky clean and sober was great—as it made me see the script she was writing each day to avoid living her own life.

She pushed me to get up and I didn't fight it, I didn't make a scene in the aisle or in the lobby. There was no can of Coke, just more certainty that sobriety means aspiring to something like the greatness on the stage not the distracted comfort of her cage. I would not be dragged around by my dick a month longer. I found a set list on the internet years later. I think we missed six songs. What a witch.

#3. "Raise a tent of shelter now, though every thread is torn / Dance me to the end of love"

For years it seemed he would never come down from the mountain. Leonard was up there meditating and the songs were just out in the universe reaching more folks. To tell people I had seen him twice was to flat out brag. But then Tom C from high school emailed and said he had extra tickets for LC at the Nokia, did Leigh and I want to go. Oh and by the way, second row. Well that was a treat, the best show, the longest, most-involved, most revelatory show of the three and no drama for me or Leigh, just adults getting

together with a few other couples before and after the show for pleasant talk.

LC opened the show with "Dance Me To The End of Love" and we were all still going thru metal detectors—no cans of Coke, no Coke at all—and we miss it so after almost three hours he closes the show with that for all the folks who missed it the first time. By this point I am exhausted, Leigh is in ecstasy, we are both limp from being in the presence of majestic genius. But this time I do have the dough to at least buy us each a shirt and she has the time to wait in line as we are walking out.

We'd seen all that a poet, prophet could deliver and the only way to tie it up was to know that we were in the right place at the right time in our lives and that is when dancing to the end of love really means forever. No other performer can inspire the range of emotions from raging loaded to bitter scorn to the bliss of a soulmate like Leonard Cohen does for me.

So on his 80th birthday I just had to rewind the tape of my life and see if the blurry memories could unite as semblance.

There.

Happy Birthday, Leonard.

Dance Me To The End of Love.

• September, 2014

The Impact of Lucian Freud

I never gave two seconds of thought to Lucian Freud before 2003. He was always an antiquated backward figurative oil painter in my mind, something to whisk by in a museum on the way to the toilet, the exit or something trendy. I didn't care about his auction records, that he was the grandson of Sigmund Freud or that he represented the part of England that never really got over having the shit bombed out of it by Hitler. He wasn't modern, he wasn't postmodern and back then those labels seemed to matter… until I actually walked through a cohesive collection of his work.

His 2003 retrospective at the Los Angeles Museum of Contemporary Art stunned me and really cracked the ice in a jinx-busting dose of reverse psychology. Here was a painter neither postmodern nor modern whose prodigious ability to regularly produce masterpieces made both of those arch-movements seem like fads. Freud was working forever as the fads came and went. Whole epochs seemed to shrink in significance before I had finished seeing half the show.

After really seeing the power of Lucian Freud, my approach to viewing anything asserting itself as a finished product was recast. I went back every week to see that show. Critically, the way one could look at work seemed to need a new methodology. I began separating painting from art itself.

Painting became something separate from art in the map of my mind. Lucian Freud was the crowbar. My critical litmus looks at painting as an epic form permanently reflecting what no other medium reveals about its times

in the utmost scenic simplicity. Painting is separate from the boring mainland of Art. Now art is just the byproduct of a bunch of masturbating dolts talking about what they are going to do when their parents lend them the money to play to a supporting crew of jabberjaw pseudotheorists more aptly described as groupies.

I had convictions about "Art" until I saw what Lucian Freud did with paint. Just about everything that isn't oil on canvas has since been found wanting. Every didactic assertion of historical importance has melted in the heat of a casual scrutiny of imagining some dull object or action standing the test of time next to a real painting. Encountering Lucian Freud forced me to rebuild the entire canon in my mind because it had been subsumed completely in my heart.

Freud was as conceptually brilliant as he was aesthetically dexterous. The unpredictability of his mundane subjects chattered like background conversations in a smoky pub while his orchestral brushwork sang like the fat lady reaching her high C. The cacophony of those abandoned to rags and the stench of their own naked decay was made majestic with the pictorial effort that Manet had approached and Bacon had approximated but only Freud consistently poured from his skin into the skin of his subjects and the souls of his viewers. Like car wrecks, their majestic grossness made me look closer and stare without shame. Like orgasms, everything about them was perfect in the mind and soul despite being the ugliest puddles in the room. And it was like this with every painting of his. A redefining of the natural order of things was the least my vapid mind could form.

Lucian Freud, 1922-2011. Rest in Immortal Peace. Your painting will be doing the work for a millennia at least.

● July, 2011

Lou Reed—Don't Settle for Walking

I was really into Lou Reed. In 1981 you couldn't just download everything he had ever recorded. I would see him and the Velvet Underground referred to in punk zine interviews with bands when they would talk about their influences. This was exactly how I discovered Charles Bukowski and Lou Reed.

Bukowski was difficult enough—few bookstores carried his books, but there was something out there. In 1983 I got a record store in Dubuque, Iowa to order *The Velvet Underground and Nico* with payment of $14 and change up front. I remember walking back as the first snow of the winter was falling—I was a California boy in college far from home buying an album by a band that I had never heard and walking a four mile round trip for the privilege.

The album utterly changed my perception of what songs could be. It sounded so far ahead of its time seventeen years after its recording. It kinda still does. My whole year at Clarke College was spent acquiring Velvet Underground albums, books, all ordered from far away, and listening. Listening, listening, listening.

Before I heard Lou Reed, music came in strict categories. After I heard him I realized "OH... there is an epic number of possibilities to make great art that defy pinheaded labels." I understood Bob Dylan perfectly because the Velvet Underground made his output make sense. In embracing all art after that I have had to laugh at pissant tiny box categories that establishments demand. I never respected a dictionary or encyclopedia since.

Consider the range of Lou Reed. Sure, David Bowie covers his rocking "White Light/White Heat" and there is

no substitute for "I'm Waiting for The Man" but these were written and composed by the same guy who wrote "Candy Says," and "I'll Be Your Mirror," let other people in his band sing them while he lingered on your "Pale Blue Eyes." The breadth of just the songs listed above span radically different approaches and yet a Velvets album would pile them in with more and shift gears more smoothly than an Indy car driver.

 I listened to the Velvet Underground and some Lou Reed so much that those songs are in a way always going on in my head. Lou Reed to me was like a god of cool who was an impeccable arbiter of what was in and what was out. And the girls who could venture a thought in two parts of their cerebellum, who had taste, who could hold on through his thrashings specifically because he soothed on that macho harsh with his melodies and vulnerable poetry, those were the girls in my dorm room before the college burned down.

 So then the weirdest thing that ever happened to me up to that point in my life happened. I'm in a living room in a small town in Minnesota with this girl, my girlfriend then and we are watching television and a commercial comes on and it has all sorts of shots of New York city and music that sounds like Lou's "Walk on the Wild Side" his uncensored lone radio hit.

 Well this is too much; I begin my twenty-year-old pontificating about how the media was ripping off Lou Reed and how he was one guy who would never sell out to an advertisement as he was the coolest man who had ever lived.

 So then just as I paused to pat myself on the back for being cool enough to express how cool Lou was, well, there was Lou, on a goddamned Vespa. "Hey!" he snarled at the camera, "Don't settle for walking."

The sinking feeling—like when your team loses a big game—overwhelmed me. The sinking horror was only compounded by that girlfriend howling with laughter, reveling in a moment of my humiliation. What the fuck had just happened.

Lou Reed was too cool for that rigid boundary of art and commerce. And he probably needed the money. But he made me understand that selling out isn't what I thought it was. He never sold out to his music, his muse, his art, his legacy. If you listen to enough of the sounds he produced on a guitar and the mesmerizing talk-singing he pulled off, you realize he could have sold out in a minute.

That teenage lover of mine rubbed it in and it took a while to digest and I ended up the wiser for it—you can do whatever you want and if you are still you... well then, what's the problem?

Mighta been a year or two later, back in LA, the redhead in Hokah, MN a tragic memory and it was with a brunette at a trendy bar- as trendy as a suburb would allow, we are talking pink neon 1980s margarita on clear plastic tabletops with nonstop rock videos playing as the substitute jukebox. This girl is buying and so there I must sit, suffering through the slings and arrows of outrageous synthetic garbage when the synthesizer drivel is interrupted by a phone ringing. This is a generation before cellphones and there is just a loud phone ringing and people, the dweebs of the mainstream that I live to be different from in my twenty-something alcoholic desperation to break out of it all, these mulletted Camaro drivers and their sorority dates are looking around, irritated. Up on the video screen Lou Reed is standing in a phone booth—the phone just rings and rings. The song finally starts, "I Love You Suzanne", his pop apogee, and a bit of order is restored to the suburban pseudo-debauchery but I enjoyed that kick to the shins he

gave every blended strawberry-daiquiri in that place with just a recorded sound that you know he insisted begin the video. It was simple, it pissed everyone off and then it was a pop song—now that is great art.

But the dark side has consequences and the one man to rage negatively against Lou was John Lydon aka Johnny Rotten who saw his friend Sid name himself after Reed's rocker "Vicious." One could not imagine the Sex Pistols without Lou Reed's innovations, his breakthroughs, his art. But John pointed out that Sid bought into the glamour of drugs and played around too terribly deep too quick to even know what was happening to him. Funny that John would be on the same conceptual dais as Tipper Gore but Lou never addressed the karma of making the scabies of a street junkie more fashionable than Versace. He was too loyal to his art to care about consequences, impact or body counts. Maybe we added the sex appeal to his missives and he was just warning us anyway.

If they take my brain out of my body at death and hook it up to a machine to see what is in there, the four Velvet Underground Albums and VU would play incessantly, intertwined with most of my thoughts and perceptions before they just up and blew out the speakers of their contraption at some point. But not before the loop of that girlfriend howling in laughter arose—reliving the time he showed up on teevee to show me he was so far ahead of me that I better not settle for walking if I really ever wanted to be as cool as him.

● October, 2013

A Convergence of Four Art Critics

This is a story about four art critics. Four white male art critics. The first is the most famous, Robert Hughes. His role in this story is small though, he started this whole narrative rolling by waking up one day late last year and dying.

The second art critic is the second most famous and by far the smartest. His name is Jerry Saltz. I actually feel terrible about Jerry even being in this story. I feel worse for Jerry being in this story than I do for Robert Hughes dying, really.

Jerry is ahead of every art critic when it comes to the communication of ideas. Robert Hughes was the worst. Robert Hughes came from the old school. He spoke on television. If he said an artist was great, nobody spoke back. He wrote for Time Magazine. There might be a letter to the editor about what he wrote but you know they get thousands of letters and are going to publish the one about Nixon not the one about art. Hughes could spout sexist, racist and homophobic slurs and never actually suffer the indignity of reading a counterpoint. Jerry though, he will have none of that hierarchy. Jerry is an art world lifer who jumps into the fray and holds his own. He writes the traditional reviews and features and, like Hughes did, he too makes appearances on television.

But the brilliance of Jerry Saltz is that he understands the old way of speaking is over. He understands that almost everyone who cares enough about art to read his writing

probably has a passionate, informed opinion on the subject as well. And his genius was in letting them express exactly that, on his FaceBook page, where he has thousands of friends, many of whom are almost as articulate as he is. While the fray at some of his threads can be heated and intense, Jerry moderates the discussions with aplomb and is quick to scold someone who hits below the belt. I can imagine he has chased off his share of nuts as he discusses everything from Modernism to the definition of prayer. The payoff has been a far richer brand of art discussion than any one person could provide. The meritocracy of articulation that appears on even the simplest subjects is at times astounding. The elite is as dead as Robert Hughes speaking to a silent audience.

When it comes to Jerry's style, though, few can match his combination of controlling the editorial direction of his legendary FaceBook page and his self-awareness within the crowd. He is not a preacher. He is not even a teacher. He has seized upon a way to make the medium of social media a viable outlet for art criticism. You can learn more about art and the art world from Jerry's FB page than you can from an art graduate school. And his FaceBook page is, of course, free.

Jerry made a FaceBook post about Robert Hughes soon after the elder critic's passing. You have to understand that a large percentage of the international art world reads Jerry's FaceBook page. He erased his Bob Hughes comment a little later. I never saw the post but, in a shining example of his fearless self-criticism, Jerry wrote a follow-up post, explaining that it was probably less than gracious of him to have candidly assessed a man so soon after his passing. You have to understand that Hughes brought this

out in people. Robert Hughes was like the short guy at the bar who picks fights and wins and leaves you standing far back grumbling about everything you dislike concerning him. But there was no outlet in existence for one to really ever "go after" Hughes and so here is Jerry, confessing he may have gone too far:

I posted something about Robert Hughes a few minutes ago.

I see that it could stir up bad blood. At the wrong time.

I apologize. I have deleted my comment.

Wow, pretty cool, not only the deleting but the complete admission of having gone too far, and in a way, illustrating that Robert Hughes had the ability to bring out something in people, even if it was tinged with a little rage of being left out of the conversation.

So the conversation starts in regard to Jerry's post about the deletion. The people who saw the post before it was deleted say it was no big deal or say it was good Jerry took it down, the ones who are late to the party beg him to repost it soon. And on and on. If you are one of the 30,000+ subscribers to Jerry's page, this is the daily routine. This is 21st century art criticism, pioneered ahead of everyone else by Jerry Saltz; nobody preaching from the mountain, the classroom or the television station. True dialogue.

Enter into the fray our third art critic, David Rimanelli. The art world doesn't have a Pope, but if it did, David Rimanelli would be his editor at the *Roman Observer*. This is one of the big dogs. This is the establishment. When you

look up articles David Rimanelli has written for *ArtForum*, four things jump out: the page goes on and on forever and the names of the artists he has written about in that premiere art world publication is a cross section of every trendy artist that has "made it" in the New York art world and translated that success into institutional respectability at the museum level. The third thing you notice is that his articles are okay, nothing special, no great insight into life, lots of art jargon and pretend historicizing; he is enamored with his subjects because of their lofty art world status, never giving us so much as a gem observation that helps define them or their art. He is not the Pope, David Rimanelli doesn't canonize the saints of the art world church, he just party-lines them as the press.

The fourth thing you realize about David Rimanelli's extensive *ArtForum* contributions history is that he wrote a bunch of art world society columns in the magazine over the years. You know, just David the ordained hanging with the one percent and their court jesters of the month. All good. Except for the fact that you know everyone he socializes with reads his society column and never read his Plain-Jane essays about the latest ice cream flavor at the Baskin and *ArtForum* counter.

So suddenly, on Jerry Saltz's FaceBook page is the cheerleader of the billionaire materialist aesthetes of the world, David Rimanelli. In response to Jerry's mea culpa over Hughes, David posts on Jerry's FaceBook wall. He rambles his self-serving blah-blah-blah and adds this nugget of wisdom on the recently departed:

... (Hughes was) an art critic who whatever his faults hasn't been a force in the art world since the '80s. I've been known to make harsh comments myself, some of which I later regretted.

Fair enough remarks about Hughes, but hardly anything approximating elite or intellectual. The internet has a way of democratizing things.

So here is David Rimanelli, a poseur, a conformist, a dedicated follower of fashion and dullard at writing society column coverage. Up to this point, historically, Rimanelli was like the planet Uranus—everyone in the art world understood he was circling around out there, massive, but they could never see him. Suddenly he was there, on Jerry's wall, posting three times in succession about crud nobody cared about and offering another garden variety opinion that carried no weight, unless you happened to know that David drew two paychecks with impressive addresses: *ArtForum* and Yale University. He was a writer for the magazine of record. Thousands of people paid a few dollars to subscribe to this art world yellow pages of gallery ads and self-congratulatory wordy P.R.-stroking disguised as theory. And he was a professor in the Yale art department. People paid tens of thousands of dollars to converse with this man. All that prestige and suddenly, we looked and here he was, naked and exposed on the internet. And he was just one of a bunch of posters, there was no there really there. At all.

Since Rimanelli had said nothing of substance on Jerry's wall, had only posted to show that he was there, posting, he got no replies, not even from the kiss-ass contingent of Jerry's crowd that makes sure to compliment anyone with art world status. A good point posted gets

rewarded with attention. An appearance, a pose, an announcement that one was there, HELLO, was met with silence. Lots of the posts on Jerry's FaceBook wall are met with silence and the beat goes on. Lots of minor celebrities are met with semi-worship. The big dog had garnered no attention, no feedback.

Now comes the fourth art critic in this story. Me. Basically, I could blah blah blah blah you with a list of what I have done, inflate it, bake it, whatever. I ego-identify with being an art critic and have been doing it in my own way to some measure of success for twenty years. But here is a little history. I was the first editor/publisher to apply popular journalism in coverage of the art world. Top ten lists, gossip, the whole *National Enquirer* playbook, I embedded it into regular coverage of the art world. Read the blogs out there and understand I pioneered the contemporary art world gossip column and all the fun ways to look at the art world outside of bullshit Rimanelliesque society columns. I created the first issue of *Coagula Art Journal*, published in April of 1992, and in it is the template for an art world gossip column, the first since at least since Vasari, and if history finds another I can safely say I had no idea it existed (based on growing up watching Rona Barrett dish it on the tube instead of watching that Robert Hughes balderdash). And I have been reading David Rimanelli's tripe for a long time (and never impressed) and marvelling at Jerry's FaceBook experiment for a little while. I realized that the chance might not come again to point out that Rimanelli might be a has-been.

So I just had to do it, I had to get in a zinger. I posted a retort to his crack about Hughes not being a force since the '80s by saying that Rimanelli hadn't either. Satisfied with

my little middle finger treatment to another brick in the art world wall, I went off and read other FaceBook stuff. Well I did not realize it but the genius behind Jerry's moderation is that you can only criticize Jerry. Here I had criticized someone else, David Rimanelli, on Jerry's wall and that was a no-no. Not because he was who he was but because he was anyone posting there. And so on Thursday morning I find a FB message from Jerry clearly stating the rules, that only Jerry can be criticized on Jerry's FaceBook wall. Jerry was friendly and explained that my number of chances in this matter is not infinite. Yikes! I had no idea and expressed my regret to Jerry who was pleasant throughout the exchange.

So about a day and a half after I perused Jerry's page I get a shockingly vitriolic personal message in my FaceBook message center. It is a FB Message to me from David Rimanelli and it reads:

You are a filthy piece of SHIT.
You ought to die in a grotesque and frightening way.
People like you ruin the world.
People who not people (sic). They are nothings.

Floored does not begin to describe my sensation. This kind of language does not shock me. I've prowled like a panther on plenty of internet message boards, forums and communities and read much more insane shit than that. It is just that I have read it coming from people with no status in the world, with no accomplishments, no prestige to speak of. This is a professor at the Yale Art Department wishing me dead because I posted "takes one to know one" as a FaceBook comment. What was I supposed to do or say?

I sure as hell was not going to apologize for afflicting the comfortable. But in my way I extended an olive branch as best I could. I replied:

Oh man I was just having fun, you are a big powerful art world person and you should be able to take a little ribbing.

Well, I guess David likes onions in his martinis and not olives because that did no good in calming him down, in fact it only made him more strident. Stupid and strident. He replied:

FUCK OFF! DIE PIG!
How dare you insult me like that,
you know NOTHING about me.
My career over in the 80s you say. When? How old was I? 20?
YOu (sic) don't count, and yeah you are right I do.

This is happening in real time—he typed it, I typed it, he typed back. Of course, when Robert Hughes was at the peak of his power, in the late 1980s, he was in his late forties. David Rimanelli turned 20 in February of 1983, so he was 25 when Hughes was the giant. And so at the time of writing that Hughes had not been a force since the '80s, Rimanelli was in fact, the same age as Hughes at his (Rimanelli-ascribed) peak.

I didn't know anything about him according to him, but I knew he was about to turn fifty and his transparent insecurity was laughable. All his career accomplishments and party invitations had not stopped him from being catty about Hughes and the coincidence that Hughes and he were at the peak of their power at the same time in their lives made me almost feel sorry for him.

But then he slipped even lower in my esteem. Hilariously. David Rimanelli messaged me:

Do me a favor, please unfriend me right now. I don't know how to do it, so if you want to do me a courtesy, do that.

I couldn't hold back. I now had proof that he was past his prime; if Hughes had lost relevance at age 49 so had Rimanelli, indefatigably. Here was an alleged intellectual who could not figure out how to defriend someone on FaceBook (and I have to add here that he added me as a friend a week or two prior to this incident). It was pitiful, but I twisted the knife in my reply:

The head of Yale Art School (sic) cannot figure out how to defriend someone, this is pretty awesome.
You want me to die but only AFTER I defriend you.

To which he magnanimously responded:

You can live; just defriend me.

If you are one of the billion people on earth with a FaceBook account, you may not have mastered it. And it is not the end of the world if you announce that to anyone. To everyone. But in not comprehending what you are doing in a public forum you do tarnish your reputation, that is, if your reputation rests on not looking like a complete obsolete square. David Rimanelli was right about Hughes being of no consequence after the 1980s because he was projecting where the whole technological revolution was leaving poor old David Rimanelli, about to turn fifty. Obsolete. And he posted this psychological self-gestalt on the very forum that has made a dinosaur out of his kind,

Jerry Saltz' FaceBook page. And I ribbed him a little just to confirm it and got a response no one with a sense of what is over and what is just beginning could have dreamt of. Confirmation.

But let's go back to Rimanelli's initial comment. He did something that reveals one of the core wrongs of the art world. He reduced. He reduced Hughes to not being worthy of respect or reflection because the man had not had any impact since the 1980s. People who can spot good art are people who know how to spot the best possible reduction of elements producing the maximum amount of excellence. David Rimanelli epitomizes the trend in art of the past thirty years of using an ability to reduce to mimic this strength of a critic, turning said reductive ability to push anything that isn't in one's clique to the margins. Sometimes it is hard to tell when an art reducer is being critical or catty. And all of cultural development suffers when the gatekeepers are the bitches who are holding up progress. But four art critics converged one day to reduce the mystery of seeing the difference into an exercise that is as simple as defriending a troll on the internet. Anyone can do it, unless, like David Rimanelli, the pathetic little troll is you.

● April, 2013

Chapter Three

EXHIBITIONS

The futility of art criticism causes almost every purveyor of the medium to run, screaming, far away from it. At a high speed. Early in the relationship. I spent my life writing criticism in an age when the market's PR machine is poisoning consciousness and academia's insipid contrarianism encourages only a regression in thinking hidden behind footnoted word collages. I only sought clarity to love the art that I saw defeating the predictable and to hate the art that embraced the death of possibility. Most of this writing was published while the shows covered were still up. They were living testimony advocating for or against one's embracing of an available art experience. Now they are all that is left of some of these shows. Whoever said "Ars Longa" was not a curator. I write reviews because sometimes they are all that is left.

The Litmus of Richard Diebenkorn
 and Ocean Park............................. 90

Is George Bush a Better Painter
 Than Thomas Kinkade?..................... 94

Daniel J. Martinez at LAXART
 Kept *PST* Relevant 98

Suffocating in San Francisco
 with Van Gogh, Gauguin,
 Cezanne, and a Thousand Tourists.......... 105

Is *Surface Truths*
 at the Norton Simon a Big Lie? 108

Let Art Ride 111

The Arshile Gorky Retrospective
 at LA MOCA.............................. 113

Frances Bean Cobain
 Debut Solo Show Review 116

Insiders Are Not Outsiders:
 A 2014 Whitney Biennial Review 120

The Litmus of Richard Diebenkorn and Ocean Park

Every once in a while there is an art exhibit that is so perfect it serves as a litmus of each viewer who takes it in. Years later you can bring up such a show and gage many things about a person based on their response. Someone who loved it is able to start a sentence about the experience and a complete stranger who was also just as moved can walk up and finish the expression of resonant passion. People who go against the grain and shrug off these perfect shows build islands of distance that often become whole schools of thought and art movements based almost solely on the hope of storming that mainland of affirmation and finally winning the argument.

This type of divide in the presence of great art and sensitive curating is not exclusively between those who dislike an epic show and those who love it. Those who do not attend can be anthropologically understood as outcasts. You can miss a great show because you were not born yet. Otherwise, if you are an art initiate, you hear the buzz and you know there are some shows that just demand mandatory attendance. While most exhibits can be avoided with time honored excuses of "I'm so busy" or "It was too far to drive," the occasional "Epic" demands that those who care about art make the time to see it; those just posing as they toggle together a career skip out on these exhibitions at the risk of expulsion from the tribe.

The survey of painter Richard Diebenkorn's Ocean Park paintings currently on view at the Orange County

Museum of Art is one of these epic shows. If you miss this one, you are just not into art. Maybe you're buzzing around some tertiary sphere like design or product photography or academic advancement, but you are not really with those of us who like art.

This exhibit is a litmus test both of whether you make time for great art and how sensitive you are to paintings that are as good as it gets. How do you feel about being in the presence of art that hangs with the most rigorously challenging abstraction and yet is as unabashedly sentimental as holding hands on the beach at sunset? Richard Diebenkorn created mesmerizing paradoxes with these pictures that tossed away all references to representation and yet confirmed a sense of place and geography far more informed than any illustrative landscape could hope for. Deceptively simple, the placidity of these paintings is an antidote to the conceptual, but not to the intellect; in the Ocean Park series intelligence is paired with relapsing emotion.

The story of the Ocean Park series is simple enough, and it bears retelling if only to today's art world made up of dealers looking for kids under twenty-five to lead them to the next big thing. At forty-five years old, painter Richard Diebenkorn left the Bay Area for Southern California and got a cheap-rent studio in the then semi-slum district of Ocean Park, a beach-hugging sliver of houses and surf shacks between Santa Monica and Venice. An established painter of figures and landscapes who had dabbled in abstraction in his youth, Diebenkorn almost immediately returned to abstract painting in the light and space of Southern California.

Curator Sarah Bancroft brilliantly begins the chronological exhibition with Diebenkorn's first picture from the space: a small landscape painting of the view out his studio window. The topography of palm trees and the sharp architecture of simple civilization depicted here then dissolve into an echo of the spatial light of the region. The artist reiterated that dissolve over two decades in hundreds of paintings and prints, more than 80 of which are gathered at OCMA. The show opened in Fort Worth but Bancroft confided to me, "They look so good here because they've come home." Again sentimentality collides with certainty when the subject is Diebenkorn, and what might have been an unresolved collision between two diametric approaches at the hand of another artist is but a sweet blend in the work of this master.

The artist dove into this abstract sea in 1967, just when many longstanding abstract painters were turning back. Al Held famously remarked that this was the year he decided to violate Clem Greenberg's picture plane. Soon after, Phillip Guston woke up to see raw cartoon figures on his studio canvasses instead of undulating color fields. Seeing no way out by 1970, Mark Rothko slit his wrists. Instead of making any type of radical break, though, Diebenkorn married the unbearable rightness of abstraction with the immeasurable lightness of landscape. Yet, like all great art out of the 1960s, if you were doing your own thing it was impossible not to be of your time.

There are a few things that make the major Ocean Park paintings special. The scale of each abstracted landscape is wider than your arms stretching out and taller than anyone in the room (at least until Shaq decides to take in this show). This scale means you are free to see the picture

from an angle. In fact, from off to the side, the occasional diagonals pull you into the misty marine layer light as effortlessly as if you are standing front and center with your feet in the sand. The smaller works though, and there are many brilliant ones included in this show, seem to give the viewer an easier grasp on the landscape where familiar geometry contains natural color. But the large canvasses are ultimately the draw regardless of the secrets to their success one can discover in the cigar box lid masterpieces.

While many big art players (from the Met in New York, to the Sheldon in Nebraska to Eli Broad just up the coast) can afford one Ocean Park series picture, few if any have more than two. Just like the economics that turned Diebenkorn's storefront studio a block from the beach on Main Street and Ashland Avenue into a parking lot across from a condo tower on the beach, each Ocean Park painting has become an expensive piece of real estate. Viewers anywhere in the country can always see one somewhere, but seeing so many of them together is the reward here, and it is a curatorial gift rarer than affordable studio space near the beach. Richard Diebenkorn: The Ocean Park Series runs thru May 27 at OCMA and then travels to the Corcoran in DC. While this exhibition won't last forever, your chance to forever brag that you saw it in person will.

● February, 2012

Is George Bush a Better Painter Than Thomas Kinkade?

Unlike every art pundit phoning in an internet review of George Bush's painting exhibition in Dallas, I actually flew down to the Big D last week to see the artworks for myself. The exhibition is at his presidential library on the SMU campus. I had lunch at Cafe 43 there to start my visit and then paid the $16 admission price to gain entry.

The exhibit is unpretentiously laid out with Bush's portraits of world leaders hanging amidst placards recounting the visits Bush had with each leader and vitrines containing gifts these visitors brought along for George and Laura. Perhaps you never thought much about gift giving at the higher levels of power, but a show devoted solely to all this loot would be interesting. It would have been more interesting to look at the paintings in a more conventional art setting—white walls in clean, well-lit spaces with unimpeded views of the paintings hung uniformly on a centerline of fifty-seven-inches. I desperately wanted to see an indication of the chronological order in which these works were painted; it would have indicated the progress of Bush as a painter.

The quality of the works varies greatly. His Dalai Lama portrait is slap-dash terrible while the painting of Indian Prime Minister Manmohan Singh is so inventive that it is just too advanced for a novice. Meanwhile the thoroughly topical masterpiece of the exhibit—Vladimir Putin's palpably evil stare – is a triumph. Knowing when exactly Bush painted this picture would have added much to the understanding of him developing as a painter. It may have also revealed any prescience in knowing if the Russian

dictator was headed toward his recent diabolical policies.

But the layout of the paintings adopted no pretense of fine art display conventions. They hung on a dark blue wall amidst the clutter of text passages, photographs and all that ornate loot behind plexi display cases. Some were at eye level, others loomed above cases and, as the exhibit progressed, groups of four appeared, the occasional improper glare of track lighting bouncing back.

In art world shorthand Bush's paintings can be described like this: Imagine the love child of David Hockney and Alice Neel mentored in painting by Luc Tuymans. But the show had zero pretense of being presented in a traditional art setting. The curation announced that the art world is not Bush's intended audience. It brought back memories of a totally different artist...

The whole installation bordered on the tacky when it suddenly reminded me of visits to Thomas Kinkade stores back at the turn of the millennium. Nothing was a better hoot back in the day than a visit to a licensed franchisee gallery showing the giclees of the Kinkade machine. Every work revealed the charming aspirations of Middle America turned maudlin by the dramatic addition of a lone spotlight splayed across a simpleton scenic canvas. The dark walls, the heraldic framing, the implied investment value—it was a pageant of every signifier of art with none of the challenges with which great art confronts its viewers and its times. Nothing summed up the soulless center of suburban American culture more—it was of its time.

Rewind the clock fourteen years—George Bush was the president of the United States and the most popular artist in the country was Thomas Kinkade. Both were sentimentalists deemed cloying by their opposition. Each was either oblivious to criticism or disinterested. Their

styles were strictly about engaging the public without pretense or any accommodations that modernity had ever occurred. In policy and paint-stroke they pined for a yesteryear that was constructed on what their audience saw as lacking in the present day. At the core of each man's approach was an engineered simplicity to re-establish his audience's collective agreement about what that yesteryear had delivered.

But their personal journeys now seem to be eerily opposite. Thomas Kinkade evolved from an earnest art student to a much-mocked but successful careerist who incorporated Christian beliefs into his art only to see a slide into alcohol abuse tarnish his legacy and cut short his life. Meanwhile George Bush had a silver spoon party boy legacy altered by discovering Christ, sobering up, going on to a much-mocked but two term presidency and is now seen as an earnest painter.

So how does the painting of an American political conservative leader stack up against the most popular conservative American painter since Norman Rockwell?

Kinkade's signature work invokes a rigid realism that Bush seems to aspire toward. While a painter can be trained, an artist must be born at some point in the process. Kinkade never deviated from the most predictable compositions and leaned heavily on the techniques of nineteenth century classical landscape painters. Bush is far more complex. He has been quoted as approaching his painting teacher with the self-assurance that "there is a Rembrandt in me trying to break out." He hasn't gotten there yet but he has developed a consistent visual vocabulary that has more hallmarks of originality than decades worth of Kinkades.

Bush paints with an economy of means, rarely building up any paint above the surface. He avoids the ultimate

trope of the novice—symmetry. His subjects all have distinctive facial structure where most amateurs plot out faces on a grid. Bush's limitations are in not mastering the layering that oil paint requires of those seeking realism. This is where Kinkade runs circles around the former President. But Kinkade's mastery of technique ends at technique. Einstein said imagination was more important than knowledge and in art an imaginative application of one's medium always trumps the systematic conventions of copycats. Thomas Kinkade is a better technical PAINTER than George Bush, but in his inventive quest to develop a visual vocabulary that captures an emotional recollection of the world leaders with whom he bonded, George Bush is already a far superior ARTIST to Thomas Kinkade.

● April, 2014

Daniel J. Martinez at LAXART Kept *PST* Relevant

By now Los Angeles is awakening to a *Pacific Standard Time* hangover and if we never see another black and white photo of a wannabe beatnik sucking up to Walter Hopps we might make it through the decade ahead in one piece. It took me a while but I finally found a *PST* exhibit that was actually focused—really, it must have snuck past the Getty's seeming mandate to diffuse all important art by piling on with tangential artists in order to water down all but the pre-approved usual suspects. Additionally this was perhaps the youngest artist making rigorous work in the time frame under consideration for the *PST* brawl.

Two series of work from the late 1970s by Daniel Joseph Martinez squeaked into the Getty's mishmash at Culver City's non-profit LAXART gallery. The La Cienega Boulvard gallery space didn't take the easy *PST* way out and spoon-feed New York some "LaLa Land" story. These two photographic series on display dealt with body augmentation as a form of irrepressible politics. Unlike ninety percent of the *PST* exhibits that looked like the history of art school professor art, the conceptual prescience and elegant presentation of subjects that today border on both the ubiquitous and nostalgic carried a dramatic staying power. I had to visit this show three times to tackle the layers of possibility that Martinez was mining during the Jimmy Carter administration—an anarchic sub-epoch that the Getty couldn't quite whitewash into minimal oblivion. I discussed this and more with the artist:

MAT GLEASON: So Daniel, you are one of the busiest artists out there. Your Project at LAXART is work from 1978-79 that has never been shown—were you eager to be part of *Pacific Standard Time* or were these pictures always just ready to be worked on and then something else always came along?

DANIEL JOSEPH MARTINEZ: These two series are now some 33 years old. They were at the time in the studio but left in a box over all these years. The beauty pageant series negatives were destroyed by a flood, so the prints in the show are the original prints from the late 70s. Somehow the prints were able to survive. The body builders are new light jet prints done for the exhibition.

When Lauri Firstenberg asked me to participate in *PST*, I was excited with the opportunity to exhibit both series together in the proper context. This had been something I had wanted to do for a very long time. The conversation between the two sets of work has the potential to expand and question each other in a 21st century discourse through the subjects and visual representation.

MG: There is a prescience in you spotting extreme behavior that has now become quite commonplace—did you have any imagination about the body issues you documented becoming "the new normal" in the future?

DJM: The politics of the body has continually been at the forefront of human behavior and analysis. This trajectory started with Darwin's ideas of evolution, which set fires across numerous boundaries. Then humanity added the concept of mutation that is very exciting due to its uncontrollability ... hence its social and political agency. There is an amplification of possibilities like the ideas of Ray Kurzweil and a biomechanical future. There is the augmentation of the body through technological

prosthetics and the now common use of technology for the manipulation of the body in form and image.

MG: At the same time you were documenting these body maintenance obsessions in men and women, the punk movement was peaking with extremes in fashion and appearance on display, not to mention the radical nature of the art and music the movement was producing. Do you see it all now as reflecting a larger tenor of the times outside of the specific issues you were investigating?

DJM: I think your observations here are reflections of simultaneous social movements dispersed in many different directions. Punk music and fashion has had a lasting effect. The issues most at risk seem to continuously center themselves on power and control. In the most utopic condition we would seek debate and autonomy with social and political freedom in an open society. Instead we have a global meltdown, free market capitalism, democratic disaster. I wonder if it's just that we are alive now to witness the condition of living in the empire, or has this always been the case, this economic and military power, and we just did not witness it. Isn't it the speed of the exchange and dissemination of image and propaganda that we are involved in every day? The social media networking and Internet's massive amounts of data we are confronted with overwhelm our ability to make any practical use of the information.

The idea of immaterial labor has surfaced. Questions are arising in an attempt to contemplate if we can imagine a future of new possibilities and potential. Can we detach ourselves from the weight of the past ideologies and methods and genuinely set in motion a condition where we grasp history and the future as the fuel to strive for a condition of building a fluid and ever-changing future,

instead of the dogmatic wealth-driven nightmare we are all responsible for perpetuating?

MG: Did you know any of the people you were shooting? Is anyone you documented aware of the exhibit at LAXART?
DJM: No, I didn't know anyone in the photos. I was aware, though, that the men who were competitive bodybuilders were associated with the same circuit that Arnold Schwarzenegger was competing in. Say if we look at "Pumping Iron" and trace the history of the rise of Arnold's fame and success in the United States that led him to films and then on to being governor of California. I wish someone in the photographs had been at the exhibit or would come to the show. I wonder what their response would be to their own image from so long ago.

MG: Plastic surgery is the new normal for those who can afford it and the body building freak show mutated into a steroids controversy in professional sports. Women get "fake" breasts to compete for attention and athletes cheat with body building supplements to get fame. It is easy to draw a linear narrative in hindsight—is the value of art steeped in theory at all useful as a predictive device or just as a reflection of one moment in time of where the culture is at?
DJM: In this instance you don't need theory at all. What you are describing is hard-wired into the species; all we need to do is look out the door, a momentary glance at popular culture to tell us of the implied and socially inherited cultural norms to which we are supposed to aspire. It is just so much simpler to live in states of fantasy and projected cultural norms. Why bother, we all live in the comfort of the empire. It results in becoming numb, lazy pathological liars.

MG: Do you see a lot of discourse in the art world and in academia mimicking beauty pageant contestants and bodybuilders in their attempt to stick out without necessarily having substance—and if so, is there an antidote amidst the politics of these systems?

DJM: We are at a strange and wondrous moment right now. On one hand artists have been duped and neutered to give over all their imagination, power and intelligence to others, allowing for the making of some of the most indifferent, uninspired work I have seen in years. The response to the current Whitney Biennial is we are all happy. The suggestion to artists is to look back and then look further back when art was passive and unchallenging. All this makes it so simple to make any argument you want. Then you can just overlay layers of social photoshopping onto it. Really, It's easy to do now, you just need a new iPhone app. Push a button and it's done, onto the meaning of the work. Decoration and family fun is the mantra of the day, rather than challenging and provoking thought. Artists could be taking advantage of the great opportunity—this state of transition. Artists could be looking forward to a new and unknown future. Risk in every form should be at every level and should be prioritized at all costs. The very core of our existence should be investing in ideas that risk failure at every level, at every instance.

MG: If *Pacific Standard Time* is affirming your work outside of the contextualization of being a Latino artist, has theory been the thing that "lifted you out of the art ghetto" or is their something integral to your practice that separates it as being the work of an artist instead of being the work of a Latino artist?

DJM: There is and was a great necessity to have progressive post civil rights paradigms to dislodge the hegemonic lock

that anemic theorists had on the cannon of validating art and its contribution to the greater culture in the United States. Due to the wholesale defeat of the culture wars and the resulting need to rethink new positions, there had to be a separation between the identity of the artist and the work that he or she produced. Unfortunately we still are using antiquated categories and models of classification to organize exhibitions. The ideas of art should always be first; all else is secondary. From my point of view all tools necessary to move forward are and should be employed. This means theory, ethic, and any principled exchange systems of knowledge and ideas; artists must get to becoming unconcerned about the opinions of those who judge and dismiss what they don't understand. Working toward that which goes beyond the easy read of the past and replaces it with the unstoppable desire to jump into the abyss and perhaps never come back. To do anything in the investigation of one's ideas so we are relentless in search for what we don't know and have not discovered. The future is our only goal, always has been, always will be. I am not a Latino artist, I am an American artist; I just happen to be Latino.

MG: Do you prefer the gallery model of LAXART (small, committed and focused non-profits) to the commercial gallery model? Can you articulate what a gray area between institutions and commerce in art might look like?
DJM: I don't think we should put ourselves in the binary of either/or. Both have their purposes and serve a great number of artists. The real question is how to not be bound to either of these two systems and at the same time utilize them. This is the moment to invent as many new and different simultaneous means of the dissemination and exchange of ideas and art. One very interesting idea/

example happening right now is the Berlin Biennial. This seems to address your question perfectly, it is an institutional event curated and not at the same time. This means there is an air of unpredictability to having an open call of work and the result will be filled in by numerous scenarios. There are many good ideas being discussed these days by curators and organizers of art events. It becomes troubling when the ideas are not being put into practice and when the final lists of those included are released. Then you realize the tendency is to constantly revert to putting in blue chip artists and/or very predictable conclusions when it is all said and done. If the ideas are not truly tested in the field and embraced, what good are they? It would seem at that moment we all become armchair academic lumps of flesh merely getting thru the day basking in the comfort and softness of our own self-deception. We are in the second decade of the 21st century... why are we not bursting with ideas of an unimaginable future???

• March, 2012

Suffocating in San Francisco with Van Gogh, Gauguin, Cezanne and a Thousand Tourists

I guess I should have been a good tourist and gone to Fisherman's Wharf, or I could have been a good art nerd and headed out to see the Fisher Collection at SFMOMA. Instead I was stupidly overcome with hope. Hope that I would have a transformative art experience viewing the most reliable touchstone in all of art: Late 19th century French post-impressionism. It would have been a good day to sell me a bridge.

Calling the de Young museum ahead of time, we discovered that walkup tickets to the blockbuster *Van Gogh, Gauguin, Cézanne, and Beyond: Post-Impressionist Masterpieces from the Musée d'Orsay* were still available. At $25 apiece, it seemed reasonable considering not only the trove of immortal masterpieces on display, but also the hefty discount on plane fare to Paris to see these works when their permanent residence, the Musée d'Orsay, finishes the remodel that made this two part travelling show possible.

We arrived at 2:15 and were able to purchase tickets for the 3:00 PM cattle herding. The Disneyland-like ropes had a maze setup under a giant Gerhard Richter painting in the lobby (if it wasn't meant as a jab at Germany on behalf of France, it still is funny as one). It was a slow day at Museum Inc., with an unseasonably sunny afternoon keeping droves of tourists outdoors. At the appointed time, we skipped cattle herding maze #1, proceeded downstairs to find check-in point #2 equally empty, and waltzed past the audio tour rental booth, nestled along what ordinarily

would have been a half-hour roped-off wait. The cute intern sweetly announced "$8 audio tour, $6 for members, are you members?" ready to pounce on the purse or wallet of anyone inquiring about how to become a museum member.

At check-in point #3 we waited a grand total of 30 seconds with two other couples before being beckoned into the crowd by underworked admission guards. What had been designed to restrain our movement toward the show for up to 90 minutes took less than 90 seconds.

But that is the good part of the review. If I had had to wait 90 minutes for *Van Gogh, Gauguin, Cézanne, and Beyond: Post-Impressionist Masterpieces from the Musée d'Orsay*, I would not have started this review off as a pleasant tourist. No matter how great these pictures are, they are crammed in a basement overfilled with way too many somnambulant European tourists. The air is literally sucked out of this exhibition space. The Axis and Allied powers stand at attention with drool droplets forming, hypnotized by the audio tour as they peer into each Van Gogh impasto for a sign of life in the long-dead quaintness of their continent. There was not a single artwork that afforded me thirty seconds of contemplation without someone invading my space. I'm not asking for a private tour (I was however, sent an invite to the press preview, but a scheduling conflict forced me here on the first Tuesday of the show, allowing the sardine-can truth to come out), but show me a theater or music act with the artistic or historical impact of Cezanne and I will show you someone who is charging way more than $25 per ticket for a rare stateside appearance.

Of course the curatorial solution to the crowds is to simply hang all of the work on a high centerline, ensuring that we will see the tops of the artworks from afar and that might be as close as we get to a good view. It might very

well be worth $25 to see Gaugin's *Self Portrait with Yellow Christ* but it is not worth anything being one of 25 people crammed onto the optimum viewing real estate of six floor tiles centered in front of the picture. The whole second half of the show was devoted to the lightweight Nabis with the occasional Puvis de Chavannes garbage (pronounced: "gar-BAWJ"). For all the rare Seurat studies the show scatters throughout its Pointillist digression, the point seems to be to remind us that Seurat's *Sunday Afternoon* masterpiece is in an airy first floor gallery at the Chicago Art Institute.

Buy the book, the calendar, the posters (framed or unframed) and the mugs. But consider buying a tuberculosis test if you are ever in an enclosed space with this many dawdling droning bored fools ever again. The only thing French this show made me consider was philosopher Michel Foucault and his theories of power derived in systems of control, primarily prisons. In sympathy to the masterpieces that are sentenced to spend eternity on institutional walls, the institution now sends the art audience through mazes and checkpoints and stairwells down into the bowels of their buildings to share the claustrophobic time. But don't let the de Young dungeon scare you from visiting tourist-friendly San Francisco. Less than four hours after finishing up this mosh pit at the de Young, we were seated with 38,000 Giants fans at AT&T park for a baseball game and breathing room with what seemed like fewer people and much more excitement.

● October, 2010

Is *Surface Truths* at the Norton Simon a Big Lie?

The Norton Simon Museum has the best collection of art in Southern California. This is the last museum that should ever have to acquire modern and contemporary work to play catch-up to the art world. This is an institution that can hold back and wait for the world of art to create works great enough for its walls. *Surface Truths: Abstract Painting in the Sixties* is the title of an exhibition that has just opened there. It features sixteen oversized formalist paintings that are nothing if not classical examples of second-generation abstract painting.

 Because of the complicated manner in which the Norton Simon museum as it presently exists came to be, its holdings include these sixteen big abstract paintings from the 1960s despite Mr. Simon's distaste for nonobjective art. A few of the works in the show are by artists who are household names in households that discuss big abstract paintings (Agnes Martin, Helen Frankenthaler, Frank Stella, Robert Irwin). Some works are by obscure abstract painters. One painting is by an artist (Joseph Vaughn) who the museum admits (on the wall placard) to having no idea of his whereabouts or work after the late 1960s. Some of these works have been on long-term loan to other local museums and have now returned home.

 For all its glory, the Norton Simon is a tiny physical space and any additional square footage added to its floor space over the years has been lacking one critical component necessary to exhibiting a large swath of modern and contemporary art: high ceilings. And then of course there is the built-in bias: the Norton Simon brand

is so associated with representational work that having masterpieces of abstract painting in its collection is like having a porn star with a high IQ: the visitors are here for something else and they will hardly notice let alone ever appreciate it.

And so there we were, enjoying the remarks of Norton Simon curators Carol Togneri and Gloria Williams in a most un-Norton Simon exhibit. Or was it? Unlike any of the art that the museum is noted for, *Surface Truths* was the art of Norton Simon's own time. At the height of Mr. Simon's material lust he derided the abstract painting blossoming in the headlines around him. A master of all he surveyed, he sought to own history in the form of the trophies of yesterday. Like bold mid-century abstraction, Norton Simon had that epic American ego. As the paintings became bigger and bigger, did they not reflect some capitalist greed for real estate? Was Mr. Simon's "collecting bug" not a manifestation of a belief in nothing beyond one's own material presence?

It must, though, be asked: does this abstract painting reflect its times? Can we connect with the collective consciousness of the 1960s through this art? Neither curator in their brief remarks would venture much speculation about content, meaning or historical interconnectivity. Sixties abstraction was championed in its time as formalism; remarkably, it retains that contextual purity and is still only officially discussed in this capacity. While a brief mention of the tumult of the decade of the 1960s was included by Ms Togneri in her introduction of the show's lead curator Ms Williams, the conversation was devoted to the work's formal properties. Nobody can blame them for this—the last four decades of scholarship in the field stays in lockstep: Content is form and nothing but the form.

"Surface Truths" is, thusly and ultimately, a somber, sad exhibition. The sixties just recede further in the rearview mirror while these perfectly preserved relics are forbidden to speak to us at all. This grand art made at the peak of an empire is still confined to its materials, color and geometry. There were great Catholic painters just after the Renaissance who insisted that their work was entirely about the religious content and was not to be appreciated by non-believers for technique, influence and formal properties. They did not get their way when art history was written.

But Frank Stella's maxim of "What you see is what you see" is religiously regarded a half century later. In the mid-sixties, that Buddhist Monk was photographed immolating himself. Are these paintings possibly pictorial immolations of content? Could these artists have possibly been seeking to become the same type of phoenix as that silent flaming monk? Did these painters destroy form to create some greater meaning? That Monk annihilated form in the insane quest for results. Does the abstract painting of that same era seek a different world than one in which the dismissal of an abstract painting is the only way to celebrate it? Maybe someone somewhere sometime will give a narrative construct to this generation of painters as more than afterthoughts to the most fractured decade of the twentieth century. These artists managed to dissolve meaning so thoroughly that a gas-can could hardly have done better. There has got to be some deeper truth beneath the surface.

● April, 2011

Let Art Ride

My Curators Statement for a Juried Show

The best thing about jurying a show for an exhibit in Las Vegas is knowing everyone involved understands concepts like "winner take all" and "let it ride" and "big gamble." Nobody holds your hand at a craps table and nobody does in the art world, either. But when you win at either, the prize is yours alone, the guy next to you doesn't get the dice until you are done and no critic ever gets his name on a painting's wall placard in a museum.

If you were to show up to Las Vegas for the first time and be met with a hard luck story of someone who had gambled away his or her last dollar, the sympathy you showed would soon reveal itself as the soul of a sucker. There is no way for me as a critic (and here especially as a juror) to ameliorate rejecting an artist for a show other than to insist the cold art world out there has plenty more in store for them.

Once you lay the bet down, call it math—odds—lady luck—fortuna... in the art world call it taste—an eye—educated opinion—enthusiasm... there is no reason you were selected that could ever come close to the guts you had to make the bet in the first place, to have entered the juried show at all.

There were good submissions to this show that I took out in consideration of having the art I felt was wildest, passionately most extreme and as well executed without being like anything else I had really ever seen. I held no prejudice against any medium or conceptual device. That the works were viewed as jpegs and not viewed in person may have favored some people - the tradition of juried

shows and jammed slide projectors has never favored perfect solutions. Art itself is a celebration of the imperfect, just as a seven is the best roll except when it ends the roll you were on.

The methodology as I stared at hundreds and hundreds of artworks to arrive at these was less like following the North Star and more like picking the right table—intuition with a little pleasurable retinal intercourse. The jaded mind's eye is the only enemy in art. Glamour is the only sin. With these two rules I critique and curate with all the hope that ignoring trends of the year and flavors of the month will allow. I'm not naive enough to think that seeing any artwork or curation will change your life but I put together art shows to defy those who assert that they cannot. The CAC handed me the dice and bet on my number. The big difference is that you, seeing this show, will call the roll instead of invisible fate and green table felt; maybe that is the final combined truth and beauty of art, as a viewer, it is your call which to call your favorite.

Thanks to the CAC for betting on me. If the regional metaphors in this essay were too much, I can only apologize for being too thrilled with the art scene blossoming in my favorite city in the world to write a stuffy essay about the experience. Please enjoy the show.

● February, 2012

The Arshile Gorky Retrospective at LA MOCA

I am so sick of convenient museum narratives that emulate movie plotlines in laying out an artist's oeuvre. Curators have stopped trying to make interesting exhibits, because what they really want to do is direct.

I got wind that MOCA's Gorky retrospective followed the same pseudo-drama chronology that is castrating the art of curation everywhere and decided to see the show from end to beginning in order to privilege the art over the screenplay.

Arshile Gorky's final works are urgent reworkings of form. Viewed start to finish the exhibit makes the case for an urgency brought about by life's frustrations, aka, the tortured starving artist syndrome. But the final third of the show (or for me, the first third of the show) is, with frothy life narrative removed, one artist comprehending, digesting and attempting to work with the radical reinvention of pictorial form that Picasso churned out in the 1930s. The problem with museum placards and their convenient dates and titles and media is that they don't reference when the artist first saw the thing that forced him to make that painting. Walking through this exhibit (either backward or forward) with a volume of Picasso's work would be pointless were there not extensive exhibition notes that could be pegged precisely to Gorky's whereabouts. With only placards, we perhaps forget that a painting made in France in 1938 might not be seen, or even known about, until a decade later in the United States. There are anecdotes about Jackson Pollock yelling when he saw a then decade-old Picasso drawing on display in New York.

The painter's fury was that Pablo had arrived somewhere ten years ago that the artist himself was just approaching.

And so we can see the tattered remnants of form in Gorky's late paintings. He is trying to reassemble pictorial stability after Guernica as a still life. Gorky's wedding paintings are a desperate attempt to paint joy as reassembled form in a world that Picasso continued to reveal as too shattered to have a delicate side.

The exhibit's mid-section is a rich collection of abstract paintings. Gorky abstracted from nature to the point of illegibility, but the grounded landscape structure of so much of his mature work owed a debt to Dali. An idiot working today would not be capable of such modesty. This pre-Pop genius, though, knew to draw the straight horizon of the picture at the top 1/5th mark of a horizontal plane because Dali had done so. This is the most enjoyable stretch of the exhibit as the artist invents new approaches and tries to find form in material experiments. One wonders, if Gorky had found Pollock's breakthrough pouring technique and had abandoned the easel altogether, would he have met such a dark fate? Well, Jackson fared almost as badly about a decade later, so no need to ponder that "what if" too deeply. The early abstraction of the artist was flat and indistinct, too clunky to be an homage to Stuart Davis, too derivative to be much of anything else.

Now, if there was a worry that the show of an artist who had committed suicide might drive someone to such a dark decision, fear not. The show was uplifting as a drama of what form can be when it is constantly being re-imagined by a competent master with a fearless need to find the new. But one room did not drive me to thoughts of suicide so much as murder. The infamous portraits of the artist and his mother are stuffed into a small phone booth sized room (kids, go ask your mom what a phone booth was—it was

not a place to hang legendary artworks). Worse, there was an education lecture occurring in these cramped quarters during my visit. A vile bland piece of whitebread-docent was singsongingly asking the group of mouth-breathers, "Why would an artist paint himself as shorter than his mother?" Of the ten idiots standing stiff in her gaze, a child answered the question, "because he loves her?" Why isn't Thomas Kinkade chauffeuring this dumb MOCA docentry to work? Whenever I hear the word education, I reach for my revolver.

Working backward to the very beginning of the exhibit, you basically get the artist making the same student work you would see today. How inspiring then, for artists to see this show backwards—you are confronted with inexplicable masterpieces of abstracted form based on human scenes drenched in tradition and you end up escaping a re-education camp in time to realize that the same garbage you and your classmates are churning out qualifies you as a potential immortal... as long as you commit suicide or add a similar dose of drama to your story so the museum can get grants to its education department to dumb down your greatest moments. That is what institutions do best.

● July, 2010

Frances Bean Cobain Debut Solo Show Review

Fiddle Tim is the artistic pseudonym of Frances Bean Cobain, 17 years old, an emancipated minor, the daughter of two complexly interwoven musical personalities whose impact on culture rivals that of any of the most successful artists of the twentieth century. And she makes art.

Her debut solo show, entitled *Scumfuck*, is up now at La Luz de Jesus Gallery in East Hollywood. La Luz is the major league of Low Brow art, a big step in any fine art career. Hundreds of artists send packets and portfolios each year to attract the attention of gallery founder Billy Shire and gallery director Matt Kennedy. One can imagine that Cobain did not have to wait in the same line as every other artist, but in an art world where if you are not pulling strings you are not part of the art world, this cannot be held against the artist nor against the gallery. Since the artist is using a pseudonym, the assumption is that there is a desire to have her work judged free from the context of her famous father, Kurt Cobain, and famous mother, Courtney Love.

If that is the case, here is a review for her pseudonym's show:

Fiddle Tim is a raw artist in need of honing her above average aptitude for drawing. Fiddle Tim's drawings balance a basic illustration approach with a scruffy (but delicately painted) texture, all aptly composed and not glopped on or glittered like so much trendy low brow attempts at feigning real experience in a cartoon culture. Her themes draw from abject personalities in search of

nihilistic power: Jim Jones, infamous punk anti-legend GG Allin, and a recurring specter who makes demands of the viewer with the threat of eating the sun if they are not met.

Another recurring character is an obese nude that seems quite comfortable in his/her own skin, its rolls of flesh drawn with sickly wrinkles. These are easily the most unique and successful drawings in the show, and simultaneously the ugliest. But with her themes of tortuous anti-heroes pausing in their selfish devastation, it is no stretch to assume that her obese characters are quite purposefully ugly; one of her Obesities is announcing "I don't give a shit" in a drawing entitled *Goat Shit* (the goat he/she stands next to is the most delicately drawn character in the entire exhibit); the other Obesity is drooling at the mouth under the phrase "Chocolate from the Bald Man" and sporting a jail cell heart tattoo on his/her shoulder reading "health care."

While the work is far from trendy, it has its roots in the ever-unassailable school of black leather self-hating punk. Fiddle Tim's eight small drawings are ensconced on the walls of the gallery amidst slick day-glo acrylic cartoon popsters. But a kindred art ally is nearby on an adjoining wall where Alyson Souza's expertly painted snakes and lizards are juxtaposed with bible verses and halos and in other paintings where body organs are separated and highlighted in intricate pictorial detail. One can only wonder if the veteran painter Souza had punk scrawled caricatures filling her late adolescent art school assignments a lá Fiddle Tim. It is a testament to La Luz that the gallery can seamlessly curate at both ends of the "raw" spectrum.

But of course a second review becomes necessary knowing who the artist is. Cobain has placed her portrait of the late GG Allin in the center of this grouping of eight

framed drawings. Like her father he was punk singer and heroin addict. Unlike her father he was "pure" in punk rock legend for never becoming famous (beyond punk infamy) or successful. In punk lore, no artist went further in his rejection of all social mores than New Hampshire's Jesus Christ Allin. The daughter of two fucked-up punk rock casualties renders the son of two hippies fucked up enough to name their son "Jesus Christ." That his younger brother could not pronounce his name was how he came to be called GG, and he is pictured by Cobain bloody and brooding, his "Life Sucks" and "Scumfuck" tattoos rendered with more clarity than GG's were in real life. Anyone with a lick of punk street smarts knows that the tender sadness Cobain renders in Allin's tired eyes is also the preparation of creating ever more destructive mayhem with no consideration of the consequences. Cobain's work is at its conceptual harshest when its rendering is soft and simple. Yikes! Kind of like a Nirvana song.

Cult leader Jim Jones is pictured, sideburns and all, in *The Ballad of Jim Jones* holding a toothbrush as his victims are sperm cell-like organisms with simple faces of death. Allin and Jones are two sides of the same coin: the power of one's self-hatred as the means to destroy.

If her Obesities discussed above are self-portraits, a working through that late-teen developmental state of hating and loving our own bodies, could the eerie *Spector Hector* reveal her relationship to her deceased father? A yellowed, fetid head shaped somewhat like Gumby has an asymmetrically disjointed left eye, and its right eye is just a socket. The most delicately colored piece in the show, does it show us a vision of Kurt Cobain rejecting his daughter's love with the admonition (which is painted below the head's purple neck) "Treat me like your mother or I'll eat the sun." Does her fixation on "icons of filth" like

Jones and Allin allow Cobain to more easily accept and process the punk rock world of her destructive parents? With a restraining order against her mother and a long-dead father seemingly pictured as rotting and insisting that there can be no redemption with him, is love a luxury that this talented heiress can never afford? If so, at least Frances Bean Cobain will always have her art.

<div align="right">● July, 2010</div>

Insiders Are Not Outsiders:
A 2014 Whitney Biennial Review

Thirty years in the art world and I had never been to a Whitney Biennial. That was actually something worth bragging about and especially after having been to one I can unabashedly lament that I will never be able to say it again.

The Whitney Biennial carries immense weight in the art world. There is almost nothing in visual art that exists as a gauge, a standard, a benchmark or just a simple "this is more advanced than that." No matter what artwork you are looking at, accomplished or ridiculous, there is always a nattering nabob who will remind you that any discussion of the work in terms of it being "good" or "bad" is taboo. One of the scant retorts available at all these days is to point out that the artist one is examining had been in a Whitney Biennial. To say "so what" to that is to risk a charge of philistinism. The fear of being asked, "Are you the biggest idiot ever?" is too great—nobody can dismiss inclusion in the Whitney Biennial as anything but an accomplishment. In the land of the jaded snob, extending one's palm open near an artwork and saying "This artist was in the Whitney Biennial," is as close as it gets to being a bearded wizard uttering "Behold!"

And yet trudging through a Biennial is a time-honored pulling back of the curtain hiding the Wizard of Oz. The art world respects the Whitney Biennial artists and the market-gain they receive from inclusion, but badmouthing each Biennial is as predictable a ritual as champagne on New Year's Eve; nobody can resist using critical pontification to masquerade their envy over not

being included or not having their allies represented in a Whitney Biennial.

The 2014 Whitney Biennial is a pile of unadulterated shit. There is supposed to be a celebration because a lot of Los Angeles artists have been included, and indeed the show is less New York-centric than ever before. But it is not a show that represents the Los Angeles art scene as much as it represents Los Angeles art school insiders (art schools in Los Angeles ARE the establishment, the bubble that protects what status quo there even is connecting L.A. to the internationalist "big art" conformity machine). But that is no surprise—the Biennial is the ultimate art world insider exhibit. It is just that this exhibit sees so many insiders pretending to be outsiders. The language of outsider art is present in about half of the artworks (the other 50 percent are my two least favorite branches of conceptualism: dry conceptualism and conceptualism masquerading as rotten formalism). One could call it an outsider art show except that it is the ultimate insiders navigating the art world ladder of success with outsider visual strategies.

Outsider Bullshit
The trick to being an "insider outsider" is to make it look more obvious than a thrift store. There is macrame, knit sweaters, bric-a-brac chandeliers, sloppy ceramics and lots of wood scattered about the Whitney Biennial. There is an insidiousness lurking in the simpleton charm of this work. "Oh hey that looks funky..." is what the impulse thought of a viewer is when one encounters this work, but sadly, IT'S A TRAP! Most of this work has a tsk-tsk tongue-clicking pretension to being about something other than it is—you see, if the work were about interesting-looking art that incorporated an outsider aesthetic (or heaven

forbid were made by an actual art outsider), then it would be accessible and engaging—something that is not taken kindly in the cold art world climate of rarifying the shit out of every human experience into academic-objective "re-presentations" of phenomena. So this is never outsider-informed art; it is outsider-embellished stances, analyses and deconstructions. The Mike Kelley impulse to soul-killingly crush any joy out of the visual language of the non-elites was the most insidious twist to the worship of irony in the late 20th century. It stands victorious (and resiliently unattacked) as the mainstream default approach to art-making practiced by the insiders atop the shit heap called contemporary art at fifteen years and counting into the 21st century.

And speaking of Mike Kelley, the Laura Owens painting in this exhibit is so derivative of Mike that it reveals a new level of curatorial naiveté that has to be singled out. Owens is long out of ideas so you cannot shame the washed-up, but a curator's first job is to spot a cheat. Just nasty.

Condescending Conceptualism

The stark message about conceptual art in the 2014 Whitney Biennial is that anything goes as long as it has an art history referent. Every time you turn around there is some terrible speck of nothing teetering on a curatorial insistence that it is art and justifying it by having some tepid construct about other art, artists, art criticism, art history or another construct unnamed by the academy as of yet but definitely involving the word art. The great Semiotext series is given a vast gallery for its archives and the curatorial impulse is to make its legacy as unappealing as a library trashcan—a feeble attempt at "artifying" the installation with silver wallpaper on one wall is a cowardly curatorial act of "Warholizing" an institution with no

allegiance to something as presently mainstream as "The Factory." Even when they dumb it down, the Biennial makes sure to do it obtusely—the silver wall of Semiotext pages is not half the embarrassment as is the including of David Foster Wallace journals as "artworks" by the late author—most of them are exhibited closed or open to indecipherable pages, totally uninteresting after the connection with the author. Celebrity stands in here as a substitute for curatorial rigor, hiding behind the glamour of their names and nothing else.

A Bloodless Mainstream
Amidst the hubbub there are plenty of forgettable paintings, installations, videos that would be elevated if they were simply relegated to YouTube and too much sculpture that vacillates between appearing to be a mainstream object performing an art function or an art object performing a functional function. The aesthetic of the day is either proto-minimalism with some clever twist to make it commentary or outsider integrity as an alias for downright sloppiness. And of course, no major art exhibit these days is complete without the myriad twaddle taking place "outside the institution's walls." The Whitney brochure for the show was chock full of detritus that will be screening on inconvenient dates and times, almost as a reflex to ensure the Biennial can never really be experienced completely, and thus, can never be ripped apart in its entirety. Well fuck it, I cannot wait. This is a gargantuan turd that, if the art world need to be re-plumbed in its entirety to flush, so be it, call the goddamned plumber immediately or just give up, set the whole institutional art world on fire and at least we can roast some nice marshmallows out of the deal.

Death As Career Strategy
There were four artworks in the show that made me think. Artworks that stayed with me... that made me take to google for all of 20 minutes to ponder.

All four of these artworks had death, in one form or another, as their central theme. Some were weirdly, perhaps unintentionally, poetic but the curators made sure to kill as much of that potential as possible. The four pieces were:
- The "art group" Public Collectors presenting a synopsis of Malachi Ritscher, a musician and music-compiler who took his own life via self-immolation in Chicago in 2006 to protest the U.S. war in Iraq.
- The late Gretchen Bender had a 1988 artwork *People In Pain* completely refabricated as an artwork by Phillip Vanderhyden. The original artwork, exhibited in the 1989 museum show *A Forest of Signs* had totally disintegrated.
- Joseph Grigely discovered a caché of personal effects from art critic Gregory Battock, hidden in a studio space for decades. Battock was murdered, stabbed to death on Christmas Day in 1980 while vacationing in Puerto Rico in a crime that was never solved. Battock had an interesting life and a career in the art world that intersected with many art world luminaries.
- A "sub-curated" gallery presented a few paintings by the late Tony Greene. Richard Hawkins and Catherine Opie had been classmates of the artist in the early 1990s at graduate school. Greene passed away from AIDS complications years ago.

Each of these has an unavoidably serious topic as the pretext for the art installation. Grigley and Public Collectors have scraps from the lives of their subjects

arranged in vitrines. Whether by curatorial choice or necessity, the overall effect here is about as far from maudlin and sentimental as one gets when the subject is the dearly departed. Perhaps there are among us those who would like to be remembered through unsentimental museum wall text, but both of these subjects were screaming for a documentary film or even a coffee table book to better tell the story, to acquaint us, to celebrate a random human life with whom we might connect. Nope, the Whitney made sure to freeze dry all the passion and let didactic assumptions reign free.

The Bender/Vanderhyden artwork was more complex. In her curatorial walk-thru on March 7, curator Michelle Grabner explained that the Whitney was resistant to crediting Vanderhyden; the institution houses its own restoration department and they never get credited as being artists. Grabner apparently fought the good fight and in doing so she has sent the message loud and clear to aspiring artists: be the foot-servants of those who showed in the museums a quarter century ago to cut in line on your way up the career ladder. And on top of that, Bender's "People In Pain" is a snide, classist thumping of popular culture and one of the ugliest large works of art ever executed.

The paintings of Tony Greene, also almost a quarter-century old, were included by curator Stuart Comer. On his March 7 curators walk-thru he poignantly expressed that a generation of artists died and that their voices would never be heard and that it was important to include one from then who, absent that terrible plague, would conceivably be making art and engaged in the art community alongside all of the Biennial participants today. The amount of space devoted here is generous and the delicate paintings show a range, discipline and sensitivity

way beyond almost any other artist in the entire show. The second greatest tragedy of Tony Greene's passing after his death itself is that had he lived he would certainly be omitted from a Biennial (and an art world) that privileges the smarmy over the poetic, the academic over the delicate and critical distance over beauty.

So those are the choices—die or sell-out. Whether you're a painter or whether you're a sculptor, if you're staying alive with a sense of earnestness, buddy you're nowhere by the look of the 2014 Whitney Biennial.

● March, 2014

Chapter Four

LOS ANGELES

The art world tries to enforce an international style so that the art of the rich kids of Brazil looks just like the art of the rich kids of London. Regionalism is seen as toxic and so I must embrace it. I was born in Southern California. L.A.'s culture is just too often left defined by people who move here. I'm one of those people who, had I been born near Dubuque, would still be in Dubuque. And so the folks who move here and embrace international art about nothing are offended and made ill by thoughts of regionalism. My embrace is here with slices of Los Angeles from the past, present and future. Nothing sickens me more than someone moving to L.A. and writing about the local color and history as if it has never been discussed. We have a secret history, we natives. And we'll document tomorrow too.

Courtney.................................... 130

The God Damned Arts District 134

Kent Twitchell—
 Above and Beyond The Getty.............. 139

Silent Sunday 143

Lyle Spencer Jumps the Shark................. 146

The Warehouse Era Begins
 in the Los Angeles Art World 148

410 Boyd—The Curse of Cocola................ 152

Courtney

Someone asked if I really saw Courtney Love strip at Jumbo's Clown Room in 1989 and yes, I did, so here is the story as best as I can recollect it.

I had been to Jumbo's one other time prior to this, it is an odd little place in a mini-mall in Hollywood, maybe it has changed over the years, this is how I recall it, mid-stupor, the stage has to be entered through the crowd and it isn't a stage as much as it is an alcove. The girls walk from the back thru the audience to the stage. The floor has maybe ten tables that each seats three patrons comfortably. I don't even think there was room for a pool table but I only visited this place a few times. There is a bar at the back and a pinball machine, back near where the "talent" waits its turn.

The beer cost just a little more than it would have been anywhere else at any normal bar and you did not have to tip the dancers if you were not sitting close to the alcove/stage. Most strip clubs have engineered the tipping and lap-dance extremes of the business so that if you are just there to drink and watch you are going to be intimidated into leaving, but it used to not be like that and Jumbo's was probably the best place to nurse a beer and maybe take a nap. The girls at Jumbo's were all different shades of bad news. There was your basic Heavy Metal cokehead, jumpy girl groupies who had gone too far down the party powder highway to do anything besides make enough money for the next pile of coke. Then there were your pothead stoner types, still with a hippie look and a pretense to incorporating some legitimate dance technique into their bump and grind behind the funky little wood fence that

cordoned off the stage/alcove from the crowd. There were sad, nodding junkie strippers with oddly drawn tattoos, this was back when having one single tattoo that looked like shit still carried a "wow" factor to it. Punk was at its nadir but there were still the beer belly has-beens with 1978 shaved and dyed haircuts wiggling the flesh for a few rounds and a place to crash.

If I recall correctly, the girls had to wear pasties on their nipples and had to keep some sort of g-string on at all times. There are different tiers in the LA strip industry—very few places are all nude and I believe they are not allowed to serve alcohol and there is a barrier to contact between patron and performer. Then there are tiers where the club can serve alcohol but the girls cannot be completely nude, they can, say, be topless and wear a thong, et cetera. I have not set foot in a strip club in LA since 2001 so all these laws may have changed, but the tiers went down and at Jumbos the girls were close enough that you could slip a tip into their panty elastic but their nipples had to be covered with a pasty—so the tradeoff is you got some incidental contact but no complete visual. And you could drink. If any of the girls at Jumbo's had been a little more together to get it together, they would be stripping at a better place, the only places lower on the totem pole from Jumbo's were bikini bars, which I think are illegal now ... and that is another story, so anyway, Jumbo's was the bottom feeder of the problem girls of Hollywood substance abuse.

I went in with a friend of mine who was dating one of the strippers there. Look, I was 24 and green, and he was not too far ahead up the naiveté ladder, so in hindsight, I believe that he believed he was dating a stripper, but who really knows, the point is, I had a reason to go there and my friend was a regular, which always makes places like this a

bit more comfortable. So we are sitting there and waiting for "his girl" to go up and the chicks who do go up are, well, to be honest, they are raunchy, there is no redeeming quality to their performances. But then after the third or fourth casualty of the night there is a hush and my friend says "I think Courtney's gonna go on," and that doesn't mean anything to me, but okay, there is just this little bit of anticipation in the air and then there is a scream and a "fuck you" and then another "fuck you," it is a girl over by the pinball machine drinking a beer. She has no pretense of stripping, her top is already off and her pasties are metal spikes attached to her nipples, like on a spiked bracelet. Years later it was obvious to me that she had a boob job AFTER her Jumbo's stint, which was a misnomer if not downright false advertising about Courtney's endowment. So someone yells "Courtney" and a few other guys yell "Courtney" and some loud heavy metal starts playing and she basically walks up to the stage, jumps over the wooden fence and sits on the stage, asks to smoke a cigarette from some guys at the table in the front row, then takes one of their beers and gets up on the stage. She doesn't even dance for a beat of the song when she sees someone in the crowd and gives him the finger and spits a mouthful of beer at him, missing him, all of it landing on an empty table up front.

 She is angry at this guy "kiss my ass" she yells, waving that finger for already the hundredth time, and she has a howling voice, like a cockroach making it into your ear, and she gets a wicked look knotted up on her face and tells him to kiss her ass again, without turning around and showing her ass (no great loss). By now some other guy has walked to the edge of the stage and is holding out a dollar, she walks over and starts talking to him animatedly, about what who knows but people start screaming, the

place was basically dead but a frenzy is kind of building, and she is stoking the chaos by manipulatively sneering half glances at the audience with "I'll get to you next, asshole" telegraphing out in half-second glances oozing with contempt. She was not one of those women stripping who reminded you they hated men or reminded you that they hated you, no, she was a higher caliber of evil, her presence put you ill at ease and eye contact with the blob of tornado flesh called Courtney reminded you that you hated yourself.

I don't recall if she even took the guy's dollar but some self-loathing guys had made it to the front and were putting out dollars and she grabbed them without even looking beyond her fingers, then she got back up on stage and started shouting to the bartender, shouting and then she just walked off, turning to yell "fuck you" a few times and give the finger to three or four regulars. By now the place is hopping with catcalls and whistles and guys trying to be funny with one-liners and other guys swearing they love her, but all of them yelling "Courtney! Courtney!" with varying degrees of amazement of having just seen the edge.

My friend's only comment was that she got punched the week before and this was the mildest he had seen her. But all twenty guys scattered at those tables shouted her name and the memory stayed, it was the extreme whereby every subsequent bump and grind I have seen performed was rendered just a little duller, just a little less scandalous, meaningless and empty. That is what a visit to the edge is supposed to do. You don't leap but you do die a little.

● September, 2010

The God Damned Arts District

It suddenly dawned on me, in February of 2014, that it had been in mid-February of 1995 that Bloom's General Store opened. It had actually opened a few weeks prior, along with Coffee Strippers and they blocked off the streets, put up a music stage and threw a grand opening party.

So I posted a video of that magic night when Alberto made espressos on the back of his flame-throwing espresso rod—It was a large flatbed truck with a giant flame coming out of the rear and atop the bed sat Al, dressed as a fireman, sitting at a counter with an espresso machine, pulling espressos.

This insane contraption stood as a symbol of what the whole neighborhood was becoming—a functional artwork that produced something. And that is what it is now—manifesting the vision of Joel Bloom, Alberto Miyares and a few people who were fed up by a legion of users sucking the blood out of Downtown Los Angeles... you see... by then the whole neighborhood had been home to hundreds of people for almost twenty years. A lot of them were drug refugees and others were artists, or at least people who called themselves artists. A lot of them look back on being there as a highlight. Lots of people in Los Angeles visited the neighborhood and the abandoned authenticity of the experience was something they took home with them. Maybe they spent the night there once and maybe they left after five years of developing and mastering a drug habit but they all took one thing from the neighborhood. They took ownership. How does an owner collect his rent on a neighborhood that he does not in fact have title to?

Easy. Every time that neighborhood is brought up, the "owner" gets to insist that he was there when it mattered, that he was there when it was real, that he was there in its golden era and that we all must pay tribute to the fact that said golden era has long passed and that we never enjoyed it like the "owner" enjoyed it.

So somehow my posting a video of a 1994 Traction Avenue street fair onto FaceBook evolved into comments from people reciting lists of places that existed downtown prior to 1994, most of which were long gone by 1994. All of downtown LA was suddenly the Arts District and a gaggle of proud parents were piping in about the good old days.

The nostalgia wave on my FaceBook page implied that the Arts District had not began with the opening of Bloom's General Store. Yes there were places like the Brave Dog in Little Tokyo and Gorky's a mile and a half away in the garment district where young disaffected people would gather in downtown in the late 1970s and all of the '80s and the memory of these times rings as a benchmark of actually being in the world and living for most of these people, who are now old enough that the good days behind them way outnumber any possible good ones ahead of them.

And so I took it as a kind of scolding, which perhaps it wasn't but it was. You see there were no bunch of whinier self-entitled white kids in the entire universe than the fucks who came to Downtown LA in the late 1970s and all throughout the '80s to party. Now that isn't the worst thing in the world but the lack of self-awareness as they pissed on and shit on the neighborhood for their own pleasure is something that needs to be addressed.

First and foremost, Downtown LA was shitty. It completely lacked amenities. The buildings were inhospitable to domesticity. It was the domicile of scary outsiders avoiding contact with people for scary reasons.

The artists who moved into these cheap neighborhoods were NOT the scary people. The egos of the first and second wave of people who settled the industrial part of Downtown east of Alameda now inscribe upon themselves an edginess and worldliness that was laughably absent in the present. "Slumming It" doesn't even scratch the surface. I wouldn't belabor the point if there wasn't the ever-present cackle of superiority rolling off their self-assured tongues that I would never understand what the present day Arts District was like before my time.

Well... I understand how it was enough to appreciate being there the day it was rescued from that gaggle of cheapskate life-stylers, hobbyists and parasites. There were always good, interesting, creative people east of Alameda. There were also mountains of complainers, takers, users, bastard lowlife backstabbing connivers and that motherfucker next to you as you pass the joint and he takes the biggest hit and nobody even knows who the fuck he is except that he is here all the time and never ever has his own shit to share. Lots of those types. An endless supply of those types.

Hollywood was where the jarheads, the westsiders and the Valley types went for "edgy" back then. Downtown people were there because it was cheap, it was isolated or they had too many run-ins with Hollywood and couldn't go back. So any time someone tells you they were downtown "when it was cool" or implies some sort of glory years, understand for your own complete knowledge of what is what that, yeah, they had a great time, downtown made for some uninhibited partying, but also that by them being there that they TOOK from the neighborhood. There was no GIVING. There was fun, amazing art, wild nights, crazy times, lots of sex and drugs and rock-n-roll but there was no community outside of a circle of friends who knew

where to buy pot without driving to Hollywood or coke without driving to Mar Vista. Oh sure there were art studios galore and stabs at running art galleries and organizing exhibitions and there were little spots where people hung out and felt kinship, but all the while the neighborhood was shit, no community in any sense of manifesting as neighbors one relies upon—the folks who lived there put up with the people who hung out there just shitting on it more.

And then the LA riots scared the shit out of everyone. May of 1992 began the whitest flight from many parts of Los Angeles. Downtown, untouched by the riots, was a symbol of "urban" to every scared bastard nearby and every rent-wiring parent abroad. The place cleaned out. The rents went down. The crackheads moved in even deeper. The car break-ins (always a problem that the glory years crowd never did anything about besides complain) were the definition of regularity. The folks who stayed were forced to actually care about it all.

In 1993 George Rollins (a property owner who lived on his property) organized a neighborhood watch. The cars were not going to get broken into any more. Joel Bloom would call city hall on nuisances large and small. Alberto was like the new sheriff and wasn't always kind to the people who were parasiting off the neighborhood the most. And lots of people in the neighborhood understood the efforts and joined in. Plenty more just did their usual jackoff complaining but people for once told them to shut the fuck up. At his underground club THE CLUBHOUSE Alberto had a sign that said RESPECT was earned not given. Every momma's boy who thought he was IT because he went downtown and was a radical artist by virtue of the loft near where people sold drugs on the street was put on notice. You won't be accepted here if you aren't part of the solution.

The solution was to not tolerate the sociopathy of crack cocaine smoking. Bloom knew every crack smoker because who else buys a new lighter every day at the store. And he told everyone who would listen exactly who was smoking crack and we all knew who to watch out for and when the day came that the guy asked to borrow a hundred bucks when we all said no the puff of smoke was in another part of the city quite soon. None of this was erased in a day and not all of it left entirely, but the legendary tolerance of Downtown, the place anyone could visit, shit on and leave smiling, those days were over. It was 1993 and there were now obstacles.

Bloom's eventually moved into the Coffee Strippers storefront and Joel Bloom made sure to navigate city hall on behalf of the neighborhood. The trees got planted on Traction Avenue in 1995. And the Artist District thrives today, totally different from the days of the crack smoking whiners and much different from the day the streets were blocked off by Bloom and Alberto to signal that a new era had begun. But anyone who says they were there before then but wasn't there then is just a user, not to be trusted.

• February, 2014

Kent Twitchell—
Above and Beyond The Getty

I swore I was over writing about the half-assed "take" on Los Angeles called *Pacific Standard Time* that the Getty has foisted on Southern California. It's sloppy excuse for scholarship would not pass muster at a Community College interview for teaching assistants. Its clique of out of town assholes retelling the L.A. narrative is insulting. The complicity of the local art press is one more reminder that everyone in the art world media is a clever whore or a dumb slut. The compliant pleasure at accepting received opinion of the survey show's "importance" is a reminder that the dumb sluts are the intellectual giants in a town that only cares about the art world because it is easier to slum around than the movie business.

I swore I was done and had moved beyond it. But god damn the Getty if I didn't just get shocked all over again. The exclusion of artists is always a touchy subject. It is the curator's prerogative, of course, as one can see the curator like a film director, excising scenes from a film that do not follow a vision of sorts. Some actors end up on the cutting room floor. The curator as artist is a legitimate endeavor. But when the institution uses the rubric of "scholarship" to exclude perfectly qualified and interesting people from curating shows, well then, the artistry of curating is off the negotiating table. If the Getty is hiring curators who are academically qualified as scholars in the field, the shows in their *Pacific Standard Time* should be, well, scholarly; the shows should reflect research in a subject. When MOCA had its big Street Art show earlier this year, the curating was done by non-scholars and presented itself as

a survey done by people who had witnessed the rise of the movement first hand. Bravo. Scholarship implies that a survey will, in fact, reflect the thing which is being studied, objectively, rather than thru the investment portfolio of some dude's fanboy commercial favorites.

The Getty is delivering an extensive survey of the history of Southern California art from 1945 thru 1980. Most of the curators of the show were not in Southern California at that time. LA Times lead art critic Christopher Knight mocked East Coast coverage of *Pacific Standard Time*, implying that the exhibit was curated with New York in mind, curated so that New York would take it seriously. Why mock those East Coast writers? When I look at *PST*, all I see is scholarly careerists groveling for an East Coast gig (Knight himself is an East Coast transplant and brings his classist sensibilities to every segregated review he writes). The whole contemptible enterprise has been a handshake between art dealers dusting off crap out of the attic and academic curators dusting off their tenure applications.

The list of shows in *Pacific Standard Time* is long. The artists that were included vary in degrees of merit, quality, relevance, impact and aesthetics. The importance of all of these categories is debatable and some of them can be entirely subjective. Many of the artists who are included in these shows are ridiculously inconsequential players whose artwork is of little merit and had no role in shaping anything about the Los Angeles art scene or anything else. But they were friends of friends and someone had the old pile of art in the garage. And yet still we can be happy that someone made some art at some point in time and years later was acknowledged for going to a party or two with Billy Al Bengston or having sold Walter Hopps a couple of greenies. That is all fine. If this were a survey put together by five art dealers out to bid up the price of what they

have taking up space at a public storage unit, it would be understandable, laudable perhaps. But the vile scholars of the Getty are using this flood of nobodies and their dusty, dinky relics from the Nixon administration to appear encyclopedic when what these curatorial twits really are is "half-assed."

Here is my beef. Nowhere in the sprawling *Pacific Standard Time* exhibits is a giant of the Los Angeles art scene from that time period. Muralist Kent Twitchell is not included anywhere in a survey of Los Angeles art from 1945 to 1980. Considering that this is an epic sweep of the multitudes of movements percolating in a particularly expansive time period, this oversight is unconscionable considering Twitchell's contributions, legacy, talent, appeal, popularity, impact and innovations. This is an oversight that kills the credibility of the Getty's efforts, curatorially self-promoting as they were, mask of scholarship and veneer of academic objectivity be damned.

If you lived in Los Angeles in the 1970s, you interacted with Kent Twitchell's art. His *Freeway Lady* mural was the region's icon of the decade. In an era before it was realized that public art could function as a money laundering method for civic-embedded vermin, Kent Twitchell was the only public artist for a majority of Angelenos during that time. His Steve McQueen house on Union Avenue, his Strother Martin on a Hollywood apartment building, but most of all his *Freeway Lady* overlooking the 101 Freeway... these were the monuments of a generation of rhetoric about giving good things to all the people, of finding common ground in a search for better things. The mysterious freeway woman looked at a million visitors a week and shared a mystery with each of them... with that eerie moon and magic carpet of an afghan only deepening the wonder of who she was and why she was there and

what it all meant. And, critically, that lady put art, fine art, in our lives.

That was street art that insisted we do anything but "obey." It insisted we imagine; it didn't tell us anything more than to complete the story. The *Freeway Lady* was a lot of things. But it also was not a lot of things. It was not art about art, it was not about art world digressions and it was not about art theory suppositions. You couldn't sell it. Nobody bought it then, flipped it to a dealer and it didn't end up in the possession of the right people. There were murals then that fulfill agendas now and there are murals now that purport to have the authenticity of the past. And that is all good, and all that is important, and that is all worthy of discussion and exhibition. But if Kent Twitchell is not included in anything purporting to summarize Southern California in the 1970s, your survey is without a masterpiece, it is a corpse without a pulse, with no moon to rise and shift the tides your way, with no woman watching out for you every day. So many qualified curators were here during that time and the Getty has handed the public the vision of a bunch of librarians who dream of Manhattan while they deny us the truth about our own paradise.

● December, 2011

Silent Sunday

The cops had cordoned off the main streets around town. Mexico was playing in the quarterfinals. If they were to win, well watch out, the celebration would need to be proactively contained.

I was really rooting for them to win. I wanted to see the neighborhood happy. The Lakers had won a week ago and folks were wild, lighting off firecrackers, fireworks and screaming into the night. But that had been on a weeknight, and late. This was Sunday afternoon, there were barbecues in backyards and the traffic of everyone getting to the one place they were going to be to watch the game.

So I am doing a little yard work and I hear some howls. Seems joyous, Mexico must have made a goal. Subdued though. I hear a thud. The neighbor storms out of her house, slams the door. The cheers were from a strorefront church on the main drag a block away. The Argentinian congregation there was cheering. My silent sulking neighbor was making sure her Mexican flag was unfurled properly on its post at her porch.

The drama fades quickly and Mexico ends up losing. The neighborhood is silent as I walk the dogs. The kids who help me with yard work on Sunday are Honduran and they can tell Mexico lost too. We walk past parked cars with Mexico flags hanging on plastic window poles, flags taped across car hoods, painted with bright cheap tempera on van windows. But there is not a soul around. I hear the breeze in the trees for the first time since I moved to the barrio three years ago.

About an hour later it is time for my Sunday afternoon

In-N-Out Burger. There is one just down the street and I have had to go to great pains to limit myself from eating there more than once a week. It is always bustling on Sunday and today the line was longer than ever. The place was packed with families and couples, many in green Mexico soccer jerseys, plenty others with wildly designed Team Mexico tee shirts, freshly screen-printed for today by a dozen or more opportunist designers.

And it was quieter than a library. I waited in the solemn procession to order my food. They called the numbers and the simple processions, usually accompanied by a cacophony of screaming and gab, this glorious fast food ritual was muted completely. Everyone looked sad, nobody was talking; there was just eating and the din of the assembly line kitchen. I heard a sniffle and one girl was drying the eyes of her crying man.

I took my burger and fries to go and went across the street to the empty patio of the Starbucks. I ordered a drink there and the same scene played out, a few hushed patrons in fresh celebratory garb were out to just not celebrate. The girl at Starbucks knows me as a regular. I noted to her that it was awfully quiet. She said they had two security guards hired to stand at each door after Mexico won. They had gone home when the game was over. She said her mom was at home crying and that other family members were almost paralyzed. "At least some people came out to get over it" she said, noting the quiet crowd.

There were no smiles, but there were no horn honks, shouts or sneers. There was numb emptiness. I'm sure one day they will win a big game and the streets will buzz with joy and an edgy fear of losing control. If that mythical afternoon should bless your barrio and you see the green jerseys of the fans of EL TRI, know that the raging joy you witness counters the silent anti-sublime disconnect

of June 27, 2010 on Pacific Boulevard in Huntington
Park, the day a people were silenced by themselves and
commerce hummed on with no more sound than an ant
hill.

●June, 2010

Lyle Spencer Jumps the Shark

I just tried to make it through the official Angels site's "Angels Inbox" feature where "fans" ask Lyle Spencer questions and he gives his opinion.

So I am cruising through the column and hit this speed bump, penned by Spencer, in reply to a missive concerning the Angels' catching situation:

> *A lot of fans are down on Mathis, judging by what I'm reading, but he has the ability to be a first-rate catcher and is a better hitter than he has shown. He was confidently finding his way when he fractured his wrist early in the season, a major setback for Mathis and his team.*

How many inanities and untruths exist amidst those two sentences:

- "A lot of fans"—UNTRUTH—Every fan with the exception of the chicks who think they got a shot at his jock is down on Jeff Mathis.
- "Judging by what I'm reading"—INANITY—dude, do you watch the games, do you follow this frickin' team? Come on, it is one thing to be on the throne of neutral, unaffected judgment, but Jeff Mathis has been cheered exactly one time in his Angels career—a walk-off hit in the '09 ALCS.
- "He has the ability to be a first-rate catcher"—UNTRUTH—there are no similar situations in the history of baseball where a player of Jeff's stunning mediocrity ever rose to the level of "first-rate" anything.
- "A better hitter than he has shown"—INANITY—it is humanly impossible to be a better anything than you

have shown when the act of "showing" is the entirety of your professional performance. When a stripper takes it all off, it is impossible for her to be more naked. Once a ballplayer has a few seasons under his belt, he is about as good as he is going to get. When a baseball player's stats are examined after he has amassed 1,000+ Plate Appearances (Jeffo has 1,074) and his OPS+ is 53 and on a downward trend during his Age-27 season, you are either lying or stupid if you say that he is a "better hitter than he has shown."

- "He was confidently finding his way"—INANITY—he was lucky to be catching a stellar pitching staff to impress his manager into sacrificing offense at his position for adequacy behind the plate.
- "A major setback for Mathis and his team"—UNTRUTH—The Angels went 30-25 without Mathis catching after having gone 7-7 prior to fracturing his wrist. How did the Angels do in their next 55 games with Jeff on the roster? They went under .500 to 62-63.

So that makes three inanities and three untruths in two sentences. And it was just one small part to one answer to a fan's question, but there is not a demonstrably arguable point anywhere in it. These fans deserve a cogent accuracy. The "team store upsell" sugarcoating (which really IS the forté of all the MLB team sites) does not have to come at the expense of, uh, reality...

<div align="right">• November, 2010</div>

The Warehouse Era Begins in the Los Angeles Art World

The word in the Los Angeles Art World is Warehouse. The Warehouse Era is upon us. Galleries are suddenly going big, bigger than ever. They are leaving the traditional Westside enclaves in search of real estate to show larger artworks. Following the aesthetics and commerce of international art fairs, galleries in Los Angeles are pursuing spaces with scale to show ever more expensive artworks that take up lots of space.

This is a radical transformation of the very nature of the Los Angeles art scene, which has for almost two decades been predicated on "art neighborhoods" where art viewers can park once and see lots of art galleries. The *LA Times* recently reported that Hauser & Wirth's new Los Angeles exhibition space will be in a large warehouse space in order for business partner Paul Schimmel to curate expansive, museum quality shows there.

Night Gallery and Gavin Brown have opened large warehouse galleries in decidedly anti-glamorous sections of industrial downtown. The square footage implies seriousness while the rents are actually cheaper than a medium-sized gallery on the Westside. Resistance to downscale neighborhoods among collectors has finally dissolved—the scale of these spaces affords the exhibition of art works that are epic in size and scope. Nobody has a wall or floor space big enough for the art unless they are world-class collectors. Every collector, therefore, must venture "across the tracks" (in this case that would be east

of the 110 Freeway) if only to prove that they are "real" collectors.

But these galleries are not really after established Los Angeles collectors—a clique of debatable size, questionable commitment and even less taste. LA is a world-class art city and the biggest collectors now travel here. International collectors don't care about traffic like the whiny westsiders who claim to "look at everything" but only go Downtown for Lakers games. When you jet into town and are in a limo with champagne and a beach babe, traffic can actually be considered an urban asset. Square footage that doesn't exist on the Westside—we are talking warehouses in excess of ten thousand square feet—is plentiful east and south of Downtown.

Many longtime galleries are quietly looking for warehouse space to join this new game. The ante has been upped. I lease a 1,200 square foot gallery space with fifteen-foot ceilings in Chinatown and suddenly feel totally inadequate. Gavin Brown's new space could fit every gallery in Chinatown into its warehouse and still have room for some of his oversized art program.

The next year or two should see an interesting shakeout of longstanding gallery norms. The "art neighborhoods" may be a thing of the past and this would mean we are witnessing the end of the Bergamot Era.

In 1994, art collector Tom Patchett financed the redevelopment of a former water heater manufacturing facility in Santa Monica into a complex of large art gallery spaces ringing a parking lot. Dubbed Bergamot Station, it

radically transformed the Los Angeles art scene more than anything that had come before it. No artist, no movement, no institution and no art school had ever delivered an easily accessible and rapidly changing collection of curated exhibitions in a convenient location. In the city of the automobile, art patrons and fans could park one time and see 20 unique gallery exhibitions of the latest art.

In the sprawling metropolis of Los Angeles, there had always been a few neighborhoods where one could park and walk from gallery to gallery, but the feet would get sore and there were never more than a handful of exhibition spaces. To call any of these neighborhoods "a cluster" was always a stretch and such a description was rendered moot after Bergamot's opening. Bergamot Station presented a locale with dedicated real estate. Save for a café, the entire enclave was originally dedicated to fine art. The Bergamot Era epitomized Los Angeles—park once, see it all for free. This business model took hold in Los Angeles from that point forward. Chinatown and Culver City are the most dynamic and longstanding examples. But for how much longer?

Let's admit it: the game is changing. The world's biggest collectors need to see art of scale and monumentality as they have become accustomed to at international art fairs. The answer to this is in massive showcases and the city has these resources, to the shock of an insular Westside. The price, though, of being an international city, may come at the cost of our art community. The Bergamot Era has seen unprecedented growth within "art neighborhoods" precisely because small, entrepreneurial galleries could open with the faith that collectors visiting nearby major

galleries might also visit their spaces. Sustained by this synergy, the public has been rewarded with access to many versions of the latest contemporary art for free. The Warehouse Era will be tailored to a decidedly different collector base and might be open by appointment only. Located in inhospitable neighborhoods, there will be no next-door start-ups. There will be no opportunities for artists outside of the international art style or those who produce art on a more intimate scale. Reflecting America, the L.A. art scene may soon have no middle class.

• June, 2013

410 Boyd—The Curse of Cocola

Living in a city too long can keep you tethered to memories and make the world make less sense than if you had forgotten whole years. The blur of time can be your friend. Sometimes when you have the flu or some other painful condition that puts you in bed but keeps you conscious, just the littlest memory of the way the light came in a window at some place you used to frequent is enough to deaden the physical pain for a minute or two. You can go somewhere else and wonder what might have happened and where you might be now if you had stayed a little longer at the bar or ordered another round or gone to that party you heard about while you were drinking there. And you know the story now of how it all turned out, or at least most of it, so the memories of places in the city at the start of your movie are vivid and magical. And your memories of the people in your life when you encountered them at these places are sometimes the only things that don't blur in your recollection.

So you drive past a storefront and you recall the time you met some famous person right there or maybe it is the spot where some girl who never called you promised to call you or it might be the square of sidewalk where something so private occurred that you would never tell a soul and a tear forms in the corner of your eye as you hope the light ahead turns red so you can wipe it away and wipe the whole recollection away.

But some tiny corners of the city take longer to die. You go there and you go back there and you live a little there and maybe you even live it up there but instead of a blurry memory as you are looking for parking two decades

later, there it is. And you might go there less often and the adventures you have there might be nowhere near as fantastic years on as they were when the opening credits of your adulthood had just rolled, but the fact that it is still there, that it kind of looks the same, and the echo of all the laughter there still bounces around and reminds you of people from the past, people you cannot name and people you might name your children after, that person you hated, two or more who you pined for and that one you thought was your friend.

The ownership might change and they could even add a patio or lower the lighting, and definitely change the menu every few months, but if some things stay the same then it is still the same moment in time as the time your hand was on a thigh of someone you never thought would allow it there and the people who went on to die years ago are still walking and drinking and giving you the seductive glance to join the widening circle of self destruction and you take the menu from the waiter's hand realizing that you might not have been good at much in life but you were great at avoiding the complete obliteration that those beautiful few had found so smoothly and the relief of not having met with the bad luck seems like a blessing until the thought that the bad luck could be a day away intrudes—but you have to tell the server what you want to drink and then you forget what you were thinking about and you call the mood you are suddenly in "wistfulness" as you stare into space at the person across the table from you who has no idea that the poison of the city has seeped deep past your skin and into your fat and tissue and pinched your every tendon with regret. You are with this person, in fact, to dilute that regret in a pleasant present and ever-hopeful future. It is just that you wanted to get a drink and dinner and now you are fighting for a breath of fresh optimism.

Nothing about it strengthens you. No matter how much you have gone on to win, earn, be given, stolen or lucked upon, when you are back there, there are parts of you that are still nobody, still vulnerable and still unsettled despite all the time and all your wisdom. And if you have a shred of regret, a wondering of what might have been, a furious agony over losing that opportunity, that decade, that perfect companion, the toxic nostalgia of these time capsules buried in the city and open to the public unaware of the pain they cause after a decade's use can be fatal to the soul, the spirit; walking in the door can alone kill any reason that you have for going on.

And yet, for whatever reason, on whatever whim and usually out of a lost habit and terrible suggestion, you end up back at "this place," and if you are really stuck in a rut of the town you never left "these places." Almost the worst-case scenario is that the menu or waiter has not changed. The same waitress means you really are in a movie and your agent can get the bit player a buyout if she cramps your Oscar chances. The even worse worst-case scenario is that someone from back then is there. Back then should really stay "back then" and there are scores of literary efforts and court cases backing me up here. And the person from your past cannot do anything to make it better. If he or she runs up and genuflects and reminisces about that conversation you two had twenty years ago that changed a life for the better and that your brilliance has created a superior reality for the small segment of the world he or she has subsequently touched, you will still feel robbed for having gone twenty years wondering how to make sense of this world and of course, might feel slightly uncompensated for the great achievement you bequeathed to humanity. But you know that this terrible scenario is not going to happen. You will see someone from back then and be reminded of

a low level misery in the person of this person and the only cure is to not walk through the door. But you did, you are seated, your drink is here, your date might be wondering if he or she did something to make you a little flustered and if you are generally not prone to melancholy you are about to look quite irritable.

A person from your past should only be encountered on neutral ground. On the internet. At a convention with lots of foot traffic. In a casino on the Las Vegas strip near the exits. When you are back in the same old place and this person is there too, it is a terrible combination. Neither of you will believe it is a coincidence and will likely stumble to address some unfinished business or relive some past glory, tragedy or incident involving a crime neither of you could have ever committed. You might try to win an old argument and this person might remind you about the insulted honor of someone you disregarded. What good can come from any of this? What temporary warm feeling will not last more than a moment before a cold pall of contempt appears? You are not on your own turf and neither is this person. You are both on a remnant of fate's turf called "what might have been." Your date likes the drink, do you?

I drank and ate at this one place many times. It was just pricey enough that I didn't go there often and just great enough that I had to go there often. The food was never bad, the bar was a mirrored altar to leaving this world behind for a Friday night buzz to the heavens and there were the people. Three deep at the bar every night in 1988 and waiting an hour to get a table, sauced on two cocktails when they ordered the appetizer, getting two-thirds of their pasta wrapped because four cocktails could have been split between sixteen people and brought each a nice quick high. And the cancerous romance of the cigarette

smoke until that was banned, taken outside for an elite that truly was there to announce that they were risking it all. I took almost every second date I had there and held off heading off to there when I knew I could only afford two drinks. That time Maria and I found your wallet in the gutter with $180 in it we both looked at each other and knew there was only one place to go. Cocola. They later changed the name to 410 Boyd but in 1987 it was Cocola and you couldn't eavesdrop on any other booth as the thunder of conversation created a slapping sound against the minimal white concrete and glass and black slate decor. And the first time you heard about it you wondered why anyone would drink anywhere downtown besides Al's Bar and the girl who was just out of your league would talk about her love for White Russians and Al's Bar was a beer bar and two nights later you were showered and wearing something that you thought was mildly stylish but would look hilarious in a stack of polaroids in a shoebox that you know some coked-up goofball was taking of the LA nightlife back then. And if you bought the girl the White Russian you never got what you might have dreamed it would get you and it really got her a little more used to getting what she wanted.

People who haven't done a damn thing with their lives will throw around words like "important" and "historic." Josef Stalin made history. Not many other people have. These civic historians get whiny when you tell the story of one of these poisonous memory vacuums and you leave out telling their story. Well too bad, I have my own stupid stories about dodging responsibility and your stupid story ends up with some illusion of you as a hero and a stud and you are neither and the proof is that you believe in restaurants being important and planting your ass there every night for six months being history. The Tequila

Sunrise that they never charged you for because the bartender forgot after he had to run out after the three guys getting into the limo because they hadn't paid the bill is not history. It is your own magical moment that made you cope with your mortality a little easier. And you never felt guilty about not paying for that drink but you always wondered if he or someone was going to chase you out of the bar and demand you pay for it. By the middle of 1993 nobody was going anywhere Downtown and there were no distractions and you paid for every drink and there was no hot girl mooching White Anythings off of any guy in any bar east of Hollywood, I am not going to get into the LA debate of where the westside starts. For me it started at The 110. I moved near Downtown in 1986 and I refuse to romance its rubble yet it beat anywhere else.

 But after 1993 or so, you went there a lot less. And I went there even less than you did. But a year didn't go by where I didn't go there. Somewhere along the line the idea that the sleek minimal decor had to have art hanging up occurred to someone. Actually there was always a little art moving thru the place. Someone would put up some pictures for a month or two. When they were building what they called Library Tower, the tallest skyscraper in Los Angeles, the eighty-plus story white thing that was once the First Interstate Building but now I am not even going to waste my time googling what they call it, some artist had some plein air landscape oils of the skyline with that thing rising, half constructed, cranes painted on, three quarters finished in a sunset, steel beam skeleton in a sunrise, it was kinda neat. I was an idiot pontificating against extending Impressionism to whatever poor soul would listen and Maria would smoke and listen and years later someone else would put up with whatever rant I would muster against whatever was on the walls there and anywhere else. But late

in the 90s this establishment officially defiled the cement walls and tried to have official art shows with pretensions to gallery traditions and artists promoting their shows and there I would be taking pictures of everyone who had gone there years ago going there once again. I have pictures of people there and then pictures of them there five years later and ten years later. People drinking, smoking, laughing, making faces, holding a lover tight, looking suspiciously at the lens of the camera, making a kissy face. There is one picture from not too long ago (unless you weren't born then) and in this picture are only people who are now dead. There are plenty of dead relationships in their prime and a few where the relationship is dying right in front of the camera.

And so the people might always be there and as my hearing leaves a little bit more each year the place only gets louder no matter if they are not even one deep at the bar. The art on the walls doesn't muffle anything and never looks good and even if it sells it could have just gone out of the artist's studio for a hundred percent profit, there was no enjoyment of the pictures like there was of the steaks and the drinks and the green apple tart and the tiramisu and the ahi salad because your date is trying to eat healthy as she excuses herself for a cigarette outside and the art is no match for the girls, were we ever really that young and did we really do all that shit to our bodies that we are paying for so dearly now? It got so bad that I could never go to the bathroom there. I had a really bad trip there and those hexagonal tiles in the men's bathroom flew past me and underneath them there was nothingness, real nothingness. Oh it was a bad trip, a real bad trip, a trip to make me only drink and I went back to just drinking after that, drinking heavily, and went back even after I quit drinking and I couldn't do it, I could not go into the bathroom and then

Emmeric painted a mural in there, a distinctive mural of his expressionistic madness and I went in to see it, to see the art, and had to look up up up at the ceiling and see it with the bottom thirty percent of my retinas because seriously, I was laying on that floor when they dragged me out of there back in the summer of 1988, they carried me out the door and three steps into the parking lot and the tall bartender with the ponytail and the girl's glasses he just pushed me a little in the direction of San Pedro and my little trip went off to Little Tokyo.

So even Emmeric couldn't save me from those tiles and then I had to piss one time, and this was three liters of Gatorade from the late afternoon in there, I had to piss so bad and I peeked into the bathroom and those tiles were waiting to unleash the emptiest nihilism-inducing black hole unreality of nonexistent nothingness and it wasn't a flashback it was like a memory of a bad dream that had happened, way badder than the $8.50 1987 White Russians that girl downed and then wouldn't even talk to me. But it was 2002 and I had to piss and they had televisions in there which they did not have in 1988 when Scott the pot dealer actually brought in a TV set to watch his A's beat the Dodgers until they didn't and everyone told me people threw food at him after the Kirk Gibson homerun. I was at Seafood Bay on Soto Street with my parents that night. That is long gone too. So I went outside and thought about pissing in the parking lot and that was not going to happen and it was skid row beyond the lot, the 410 Boyd bubble of upper middle class civilization was a tiny bubble and I walked fast down the sidewalk and closer to the cardboard box homes of the crack addicts, the tents with luggage outside and I pissed against a wall. And if it had been a movie a cop would have pulled up and flashed a light on me and hilarity would have ensued. And if it had been

a television show I would have met a homeless guy and found a deeper part of my existence and still managed to keep colonial consciousness in place. But the movie in your life doesn't really happen when you are almost forty and are going back to some old haunt because some friends had an art show there. So nobody saw me piss, I got back into my booth at 410 Boyd before the dessert arrived and avoided the hexagon devil of my mind.

 You see, every visit became a chore of fighting the past. But the food was always good or even very good and once in a while it was even great. And even if I had long stopped drinking my dates were always down for a glass of wine or a cocktail and this place impressed them and there is nothing like living in the now and watching her smile after the second sip and it is hindered by that idiot waddling over, putting his hand on my shoulder and slurring some crack about the time they threw food at Steve the pot dealer and I don't correct him that it was Scott and every dollar I spent here suddenly mocks me for not investing in Apple stock and staying home and drinking Lowenbrau which wasn't even really Lowenbrau, and I did plenty of that, I didn't go to Cocola every night, I didn't go to the Boyd every night, I stayed home and passed out with the sixth Lowenbrau half-drank many times and this idiot chuckling thru his own buzz with his own delusions that necessitate squeezing my shoulder is making me regret ever having had any fun in my life. Is this what being German at an Anselm Keifer exhibit is like?

 I went to Cocola after I went to the first MOCA press preview I ever crashed, it was for that awful show *A Forest of Signs* and there I was, drinking with art people, talking about art, and someone buying drinks and in a way I was kind of born that night. And I could tell you who was there and what was said and how the interesting mix of gossip

about the people in the show and at the museum merged with the analysis of the art, how it all just turned me on, made me feel that new level of being alive, how the worst moment of my life, the hexagons, the tiles, the fucking tiles, was two hundred feet away from the greatest moment of my life up to that point, being in a real conversation about art with real art people and being accepted as someone because they had seen me at the press preview and I could make jokes about people who ordered Lowenbrau and expected the real European version of the beer and get a laugh, a real laugh.

And that was all five years after I had first set foot in the place. There was a lot more in life ahead and every time I went there I would encounter what was and the more I changed the more it stayed the same and the haunting din of the dead, the subsequently fattened, the grown old-bitter-ugly, the moved-on, the-still-there-and-now-too-judgmental, the drama that possessed people to fight old battles and play outdated games that inspired long-solved riddles. And one night I told this sober guy we should go there for a bite, could he handle being around the booze and he said "yeah" and he had a wife and I had a girlfriend and we could have gone to the Pantry and we went there instead and two kind of hot girls just ran up and hit on us and the waiter said the kitchen was closed and he looked at me and I looked at him and we drove off to the Pantry. How come that never happened in the 1980s? The curse of Cocola. The curse was that Cocola always dangled something there I couldn't have, the center of the scene when I was broke, a hub of culture when I was stoned, a wild party when I was sober, a nostalgia trip when I was actually doing my own thing and a brothel when I was monogamous.

So today, 2012, we got a restaurant recommendation from Scott, not Scott the Pot Dealer, just Scott on FaceBook, to try the new place that is there. Alright, it had been a while, a long while, despite all the ghosts, the cement walls glowing white and the long bar beckoned with a glimmer of connecting with the magic of the past. And free parking on Sundays. Opening the door was like attending the happiest funeral one could imagine. The afternoon light that had set up many a bizarre drinking story was blocked out. The white walls had wood paneling. WOOD grain? If there is anything that is the opposite of cold minimal glass and black slate tabletops and concrete walls with or without lifeless art, it is wood, recently alive in a forest and got the annual ring to show it. Wood. The whole establishment is wood. Wood floors, wood walls, wood table tops, wood bar, wood bar stools, wood wall ornamentation behind the bar. A few hints of the old place are there, the mirror on the back of the bar is still there, yes I know that it replaced the big yellow Bob Zoell painting that replaced the massive John Chamberlain wall piece (and again, this is my story, not yours, so I am not going to get into the lore surrounding how that masterpiece was absconded with, but will admit that it would make a great New Yorker article that Anthony Haden Guest could write, get rejected and slip in as a chapter to some book about the art world that is actually cobbled together rejected New Yorker articles, oh wait he already did that). The booths still have that pleasant width separating them so you never feel some stranger elbowing you from behind and so some old friend or foe from the past can set his or her drink down behind your head but not set it down on your table when the interruption arrives. The black concrete ceiling is still the same and the exposed aluminum air-conditioner vents abound, but the soft wood dulling the conversation and

the menu basically existing as a hipster Denny's is about as far from that Nicoise salad and creme brulee that American cuisine allows for. The bar is the bar, I didn't go snooping to see if they had the same bottle of Chambord that that short blonde manager with the broken nose hid a bottle of pills behind. Try a Gin and Chambord with soda. That is what Maria and I had when we spent every cent in your lost wallet, sorry. Leigh ordered something with tequila called a Diablo today and said it was great. The place is called "The Hideout" now. The theme is self-aware Western. It is dark, cozy and a tick or two above quiet. The infamously long bar is intact. But it is not the same and nobody from the 80s or 90s was there. Can we assign Cocola to the history pile yet?

Yes we can. Because, best of all, the hexagon tiles have been removed from the bathroom. I took a piss today standing on cold concrete and knew that the past was a hallucination I could finally lay to rest. And the past is best when, if not forgotten, laid to rest.

• July, 2012

Most of the essays in this book were all written at my desk at home in Huntington Park, a few miles south of Downtown L.A.

All of this book was designed by Amy Inouye at FUTURE STUDIO in Highland Park, a few miles north of Downtown L.A.; Amy is the friend mentioned in the essay on Page 25.

Cover photo: Front Porch Time Lapse Self Portrait, 2012

www.ingramcontent.com/pod-product-compliance
Lightning Source LLC
Chambersburg PA
CBHW030740180526
45163CB00003B/869